Collage
WITH COLOR

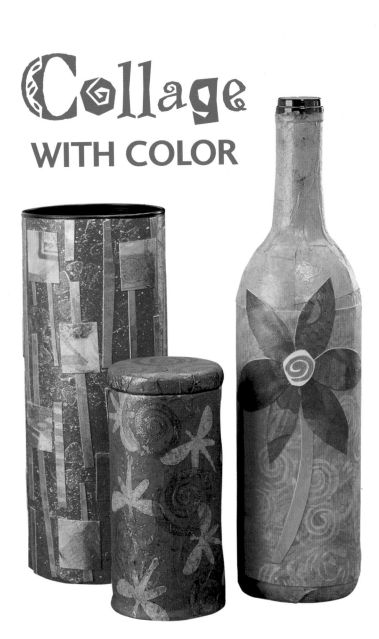

Collage
WITH COLOR

CREATE UNIQUE, EXPRESSIVE
COLLAGES IN VIBRANT COLOR

Jane Davies

PHOTOGRAPHY BY JOHN POLAK

WATSON-GUPTILL PUBLICATIONS/NEW YORK

Acknowledgments

I would like to thank my parents, Beverly and Jim Davies, for their editorial and moral support; my partner, Dean Nimmer, for his creative influence and constant encouragement; my friends Janno Gay, Elizabeth Tufts, Jo Kirsch, and Susan Kramer, for allowing me to use them as guinea pigs for some of the instructions and techniques; senior acquisitions editor Joy Aquilino of Watson-Guptill, for her invaluable contribution to the book's conception; my editor, Michelle Bredeson, and my photographer, John Polak, both of whom have been a pleasure to work with; and Areta Buk, for her skillful and creative book design.

First published in 2005 by Watson-Guptill Publications,
a division of VNU Business Media, Inc.,
770 Broadway, New York, NY 10003
www.wgpub.com

All artwork by Jane Davies.
All photography by John Polak.

Library of Congress Cataloging-in-Publication Data

Davies, Jane.
 Collage with color : create unique, expressive collages in vibrant color / Jane Davies ; photography by John Polak.
 p. cm.
 ISBN-13: 978-0-8230-0797-4
 ISBN 0-8230-0797-9 (alk. paper)
 1. Collage. I. Title.
 TT910.D33 2005
 702′.81′2—dc22

 2005011707

Senior Acquisitions Editor: Joy Aquilino
Editor: Michelle Bredeson
Designer: Areta Buk/Thumb Print
Production Manager: Hector Campbell

Manufactured in the U.K.

First printing, 2005

2 3 4 5 6 7 8 9 / 13 12 11 10 09 08 07 06

Contents

Introduction

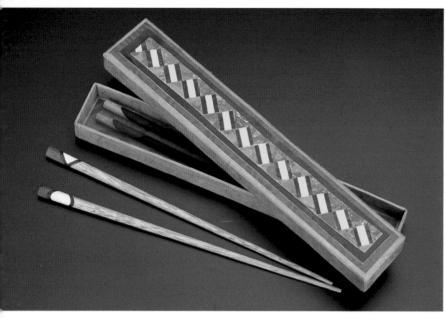

A collage is an assemblage of papers or other materials glued onto a support to create a meaningful image or decorative composition. Collage is a very accessible medium, whether or not you feel that you have any particular artistic skill. Anyone can achieve satisfying results with collage. Painting decorative papers and creating collages from them is an ideal way to get your creative juices flowing, whether you are a novice looking for a starting point, or an experienced artist wanting new inspiration or just seeking to expand your creative repertoire. The papers and collages you make can be as simple or as complex as you choose, from a single motif to a complex design.

A traditional Seminole patchwork design made of patterned papers adorns this chopsticks box. Chapter 5 includes instructions for making several types of boxes, which you can decorate with collage.

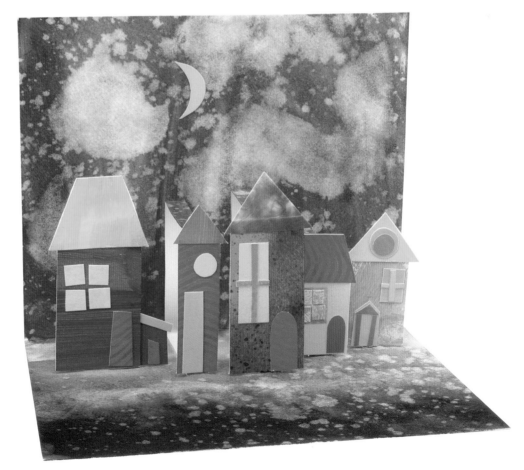

Gift tags and greeting cards, such as this pop-up card (instructions on page 99), are an ideal format on which to explore collage.

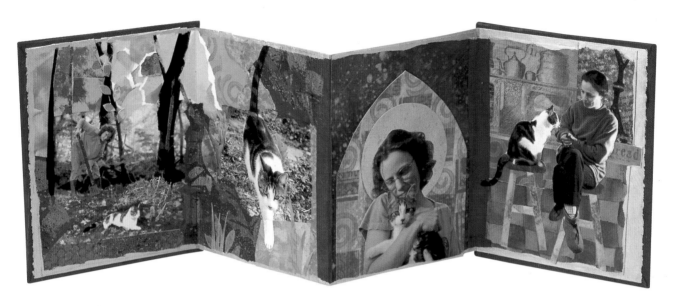

All image-making requires abstraction—taking something from the outside world, whether visual or conceptual, and expressing it in terms of shapes, lines, and colors. Collage is a medium particularly well suited to this transformative process, in that it is so explicitly abstract. A collage looks like a collage, whether it comprises abstract shapes or recognizable images. Cutting shapes and gluing them onto a support (whether two-dimensional paper or a three-dimensional object) compels you to visualize in terms of abstract elements rather than focus on accurate visual rendering. A group of squares and rectangles can be a checkerboard pattern, a cityscape, or a robot with personality, depending on how you arrange them. I think this process gets at the heart of creativity.

Collage can encompass a broad range of materials and is often associated with found materials or saved ephemera. Personal items, such as letters, ticket stubs, travel souvenirs, and so forth, that trigger specific memories can bring meaning and content to collage. In this book I instead focus on making collage materials using decorative painting techniques on paper. However, you should feel free to incorporate found materials or personal mementos into the process. I show a few examples of this throughout the book.

I have been fascinated by pattern ever since I can remember. There is something primal and universal about the repeated motif. It is found on artifacts from every culture and every time period, from prehistoric cave paintings to present-day consumer goods. Using pattern as a primary source of collage elements can transform the simplest composition into a dynamic image. Making patterns on paper and designing collages with them are process-oriented activities. You may find as much value in the activity itself as in the resulting papers and collages. You may, on the other hand, have a very specific goal in making collages—creating your own holiday cards, for example, or making your own memory books. In this book you will find the information you need for these projects, but I encourage you to let the process of painting and making collages take over and lead you in new, maybe unexpected directions.

For this scrapbook featuring my cat Simon, I used some patterned papers I had painted as well as photographs and other ephemera.

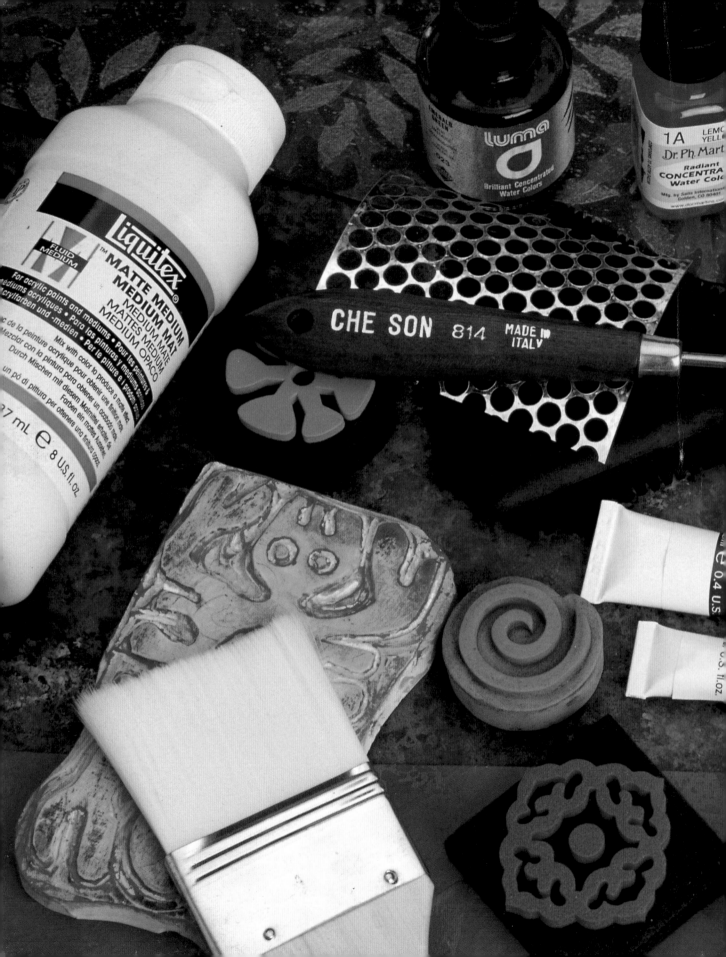

CHAPTER 1

Materials

Paper and paint are the primary materials you will use for creating colorful collages. In this chapter I will discuss the variety of papers available and the many types of acrylic and watercolor paints you can use to make rich patterns and images. Once you have a basic understanding of their physical characteristics, let the paints and papers inspire you, choosing ones that appeal to you on an intuitive level. The most important thing is to get some basic materials and just start painting and making collages. In addition to paper and paint, we will discuss brushes, acrylic mediums used to modify acrylic paint, adhesives, and a few other helpful tools and materials.

Paper

In any art supply store you are likely to find papers for every conceivable application: drawing papers, watercolor papers, printmaking papers, decorative papers, specialty papers for graphics, construction and craft papers, and so forth. Such an immense variety of papers can leave you wondering where to begin. For starters, let's look at white papers. Although I will discuss some uses of colored papers in chapter 3, for the most part the techniques I will demonstrate begin with a blank sheet of white paper.

At the outset I recommend you use the less expensive types of watercolor or printmaking papers. These are available at art supply stores and some craft supply stores and from mail-order sources. Not all drawing papers are made for accepting wet media (watercolor and acrylic paints, in this case), and many will curl or buckle after paint is applied. If, however, drawing paper is better suited to your budget (it is generally much cheaper than watercolor or printmaking papers), or if you happen to have a quantity of it already on hand, by all means use it. If your paper curls or buckles after the paint is dry, simply

flatten it by placing a piece of waxed paper or butcher paper over it and weighting it down with several heavy books overnight. You can make a whole batch of painted papers and weight them down together with waxed paper between each painted sheet.

The price of watercolor and printmaking papers can be intimidating if you are accustomed to using drawing or craft papers. A single sheet measuring 22 by 30 inches can easily cost several dollars, and some papers cost much more. However, most stores offer "student grade" or "economy" papers, which are perfectly suited to the techniques and applications I will discuss. Unless money is of no concern, it is important that your paper and other materials be inexpensive. Faced with an expensive sheet of exquisite handmade paper, you are not likely to feel free to experiment. Creating collages from your own hand-painted papers is most spontaneous (and most fun) when you are not worried about your investment in the paper.

Given the above considerations, there are several factors that will figure into your choice of papers.

A selection of papers, including watercolor, print-making, and drawing papers, and a sheet of paper "canvas" (bottom right).

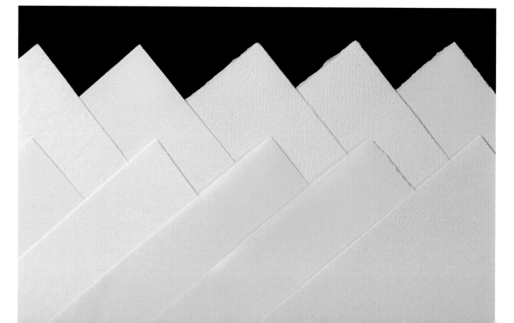

Weight

The weight, or thickness, of a paper largely determines how it will adapt to various applications. Generally speaking, the thicker or heavier a paper is, the more water it can absorb and the more handling it can withstand without curling or buckling. On the other hand, heavier papers will not have the flexibility of lighter papers.

Watercolor papers, drawing papers, and some printmaking papers are traditionally measured in pounds. Common weights of watercolor papers are 90 pounds, 140 pounds, and 300 pounds, while drawing papers are often sold in 50-pound, 60-pound, and 80-pound weights. This measurement refers to the weight of a ream, or 500 sheets, of paper of a standard size. The standard size for watercolor papers (and most printmaking papers) is 22 by 30 inches, while that of drawing papers is 24 by 36 inches. This traditional method of measuring a paper's weight may seem arbitrary and irrelevant. Increasingly you will find the weight of paper given in grams per square meter (GSM), a method of measuring the weight of a paper that is consistent across all types of paper no matter what the dimensions.

For most of the techniques and applications discussed in the following chapters, a relatively lightweight watercolor or printmaking paper (90-pound or 192-GSM) will work best. A heavyweight drawing paper is also likely to work, but you should test several types for curling or buckling before buying in quantity. You may want to choose a more substantial paper—a 245-GSM or 300-GSM watercolor or printmaking paper for example—for some projects, such as a journal cover or a gift box.

Converting Paper Weights

When shopping for papers you may need to convert pounds to grams per square meter (GSM) and vice versa. Here are conversions for some standard-sized papers.

Printmaking and watercolor papers measuring 22 by 30 inches:

POUND MEASUREMENT	GRAMS PER SQUARE METER
90 lb.	192 GSM
140 lb.	300 GSM
300 lb.	640 GSM

Drawing papers measuring 24 by 36 inches:

POUND MEASUREMENT	GRAMS PER SQUARE METER
50 lb.	81 GSM
60 lb.	98 GSM
80 lb.	130 GSM

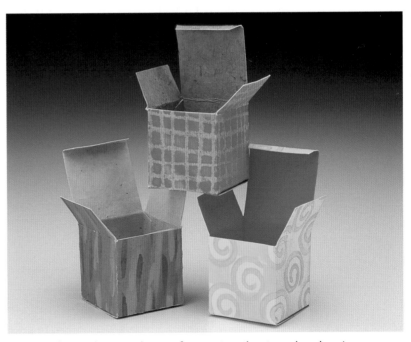

You can always glue two sheets of paper together to make a heavier paper (see "Laminating" on page 101). These tiny gift boxes are made with watercolor paper that I decorated and then laminated with solid-colored papers. Instructions for making these boxes are given in chapter 5 (see page 106).

Surface Quality

Watercolor papers come typically in three different surface qualities, or textures: "rough," which is the most heavily textured; "cold-pressed," a medium-textured paper; and "hot-pressed," which is smooth. These designations vary somewhat from manufacturer to manufacturer, but will give you a general idea of a paper's texture.

Printmaking papers are usually described in very nonstandard terms.

The surface quality of your paper will noticeably influence the character of your paint application. These examples show how different papers influence the look of a stamp application, a palette knife application, a paint wash, and a glaze. From top to bottom: hot-pressed watercolor paper, rough watercolor paper, and canvas paper.

"Pronounced" or "coarse" texture, "fine" or "light" texture, and "smooth" or "vellum" finish are typical descriptions of printmaking papers. These descriptions correspond roughly to the standard watercolor paper surfaces—rough, cold-pressed, and hot-pressed, in that order.

Some drawing papers, especially those made specifically for charcoal or pastels, are described as having a "laid" texture. This is a very uniform texture resembling that of a woven fabric. Others are described in terms similar to those used for printmaking papers.

Archival Quality

The archival quality of a paper (or other material) refers to its longevity. Will it yellow and become brittle with age, or will it remain intact? Papers that are labeled archival are pH-neutral or acid-free and are expected to last at least a lifetime without deteriorating. Papers made from 100-percent cotton rag, generally considered to be of the highest quality, can last for hundreds of years. Papers made from lesser quality fibers, such as wood pulp or a combination of fibers, can be made archival by the addition of buffers and neutralizing agents.

Most watercolor and printmaking papers, even "economy" or "student" grade papers, are archival. Most drawing papers that are heavy enough to paint on are also archival. The only papers you can be sure are not archival are very inexpensive drawing and craft papers, such as newsprint, construction paper, craft paper, and butcher paper. Colored papers, even high-quality drawing papers, may not be archival because the dyes used to color them may be acidic and cause them to deteriorate over time. Most of these, however, will take years, not weeks or months, to show their age and are therefore perfectly appropriate for many applications.

Absorbency

Watercolor and printmaking papers are made to absorb water, ink, paint, etc., but are treated with sizing so that they don't fall apart the way facial tissue or toilet paper would. Sizing is a substance, usually methyl cellulose, added to paper to control the degree to which it will absorb water (and other wet media). Internal sizing is added during the pulp stage of papermaking—that is, when the paper is no more than a slurry of pulp. External sizing (sometimes called "tub" or "surface" sizing) is added after the paper is pressed into sheets. Watercolor papers are sized, often both internally and externally, to facilitate subtractive painting techniques such as "lifting" paint (wetting the painted paper and blotting it to take away some of the color; see "Subtractive Painting" on page 75). Unless otherwise indicated, most watercolor and printmaking papers are sized and will be appropriate for the techniques demonstrated in the following chapters.

For acrylic techniques, the amount and type of sizing is less important, as the first layer of acrylic paint, even if it is a wash or a glaze (paint diluted with transparent medium), will seal the surface of the paper. However, with watercolor techniques, a heavily sized paper will not absorb enough paint to result in bright colors. Unless you soak the paper first, your colors are likely to remain pale and look washed out. Instructions for a quick-soak method are given in chapter 3 (see page 74).

Sgraffito is a technique that involves scratching through a painted surface to produce a pattern. In chapter 3, we discuss the use of sgraffito with acrylic paints (see page 58). Sgraffito in watercolor (shown here) uses exactly the same technique as that used with acrylic paint, but the results are somewhat different. Because the paper is sized, the watercolor is not completely absorbed and the white of the paper is revealed when it is scratched. Where the paper has absorbed more water, the sgraffito marks are darker.

Special Kinds of Paper

In addition to your basic watercolor or printmaking papers, you may want to experiment with colored and textured papers. Some papers, such as lokta, are desirable for their structural qualities (important for craft projects), others for their visual appeal. You may want to explore origami and other patterned papers as well as highly textured hand-made papers, all of which can be found at specialty paper stores.

A selection of colored lokta papers I decorated using stamping and light sponging techniques.

Lokta, Unryu & Mulberry Papers

Lokta is a handmade paper from Nepal made from the fibrous bark of the *Daphne cannabina* bush, which grows in the high altitudes of the Himalayas. Lokta comes in a wide variety of colors and at least two different weights. It is very strong and flexible, and because of these characteristics I recommend it for many of the paper crafts described in chapter 5. It is ideal to use for covering boxes, laminating your decorated papers, covering three-dimensional objects in preparation for collage, and many other projects. It is not colorfast, though the color does not fade noticeably unless the paper is exposed to direct sunlight. Any strong, flexible, and relatively lightweight paper will work for the applications mentioned above. If you can't find lokta, look at mulberry papers or unryu (pronounced un-RYE-you); both of these are usually a little lighter in weight than lokta, but they have long fibers and can be quite strong. (You can visit my Web site, www.janedaviesstudios.com to find sources of lokta and other specialty papers I use in this book.)

Colored Papers

Lokta and mulberry paper come in a variety of colors and are good choices for decorating using the painting techniques described in chapter 3. In addition, there are many colored artist's papers, made for charcoal or pastel drawing, that are available in art and craft supply stores at reasonable prices. These papers are not meant for wet media, so they may curl or buckle under heavy paint application, just as other drawing papers will. However, stamping, light sponging, light brushwork, spattering, and stenciling are some of the techniques appropriate for colored drawing papers.

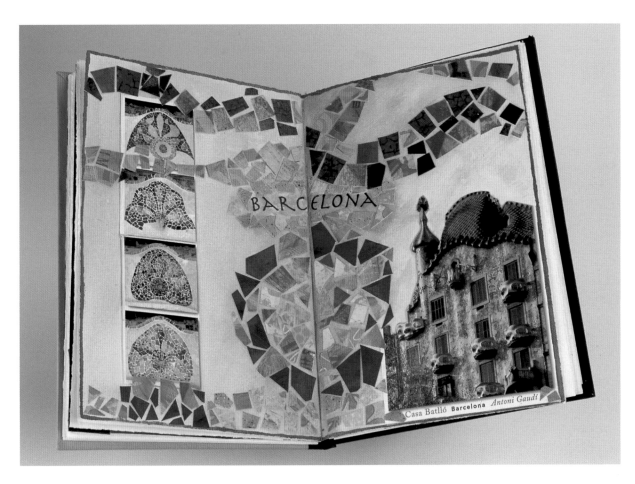

Some colored papers that I do not recommend for painting are construction paper, which is particularly short-lived in terms of color and structural integrity, and colored card stock, which fades quickly and buckles under even light applications of wet media. Card stock and construction paper may be good choices for solid-colored elements in collage projects or for the text paper in a handmade journal.

Miscellaneous Papers, Photographs & Ephemera

The discussion of papers in this chapter is meant to give you some sense of how to choose papers to decorate with the techniques described in chapter 3. However, in your collages you may want to include other papers and images in addition to your own handpainted ones. These could include found papers, such as torn book pages, wine labels, and photographs; decorative papers, such as screen-printed and marbled papers; or papers with interesting textures or surfaces, such as foil, corrugated card, and velour paper. Some of the considerations applicable to white and solid-colored papers, such as weight and archival quality, may apply. For the most part, though, it's best to just try out any paper that appeals to you. You are more likely to be satisfied with your end result if you begin with materials that have a color, texture, and overall "look" you find compelling.

In this scrapbook collage I used postcard images of Antoni Gaudí's Casa Batlló and mosaics at his Parc Güell in Barcelona, Spain, as inspiration for my own paper mosaics.

Acrylics

Acrylics are perhaps the most versatile of painting media. They can be diluted with water to create thin washes that resemble watercolor techniques; they can be layered in transparent glazes to produce deep, rich colors; and many acrylics can be applied thickly to achieve various textures. Once dry, the painted surface is durable, flexible, and waterproof. An accidental drop of water or wet paint on your finished collage can be wiped off easily without harm. On the other hand, since acrylics are not resoluble in water after they have dried, it is important to wash your brushes, sponges, and other tools immediately after use. Acrylics are available in a vast range of colors, including specialty colors such as fluorescents, metallics, and pearlescents. They come in a wide range of prices as well, so it is easy to find acrylic paints that suit your budget. You can buy acrylic paints at any craft or art supply store, and also at many hardware and home decorating stores.

Acrylic paints come in various types of packaging, including tubes, bottles, and jars.

Pigment Load

Acrylic paints consist of acrylic polymer emulsion and pigment, and they usually contain other ingredients such as opacifiers, matting agents, and water. It is the amount of pigment (pigment load) relative to other ingredients that determines the coverage, tinting strength, and sometimes opacity of an acrylic paint. Tinting strength refers to the amount of white paint you need to add to a color to lighten it to a given tint (see "Value" on page 32). The more pigment in a paint, the greater its tinting strength and the more white you will need to add to lighten it.

The amount of pigment in a given paint, relative to other ingredients, is also the primary factor in determining the price of a particular line of paints. "Craft" or "decorative" paints are generally the least expensive and contain the smallest pigment load. Within a single line of "artist's" paints, the prices usually vary from color to color, because the

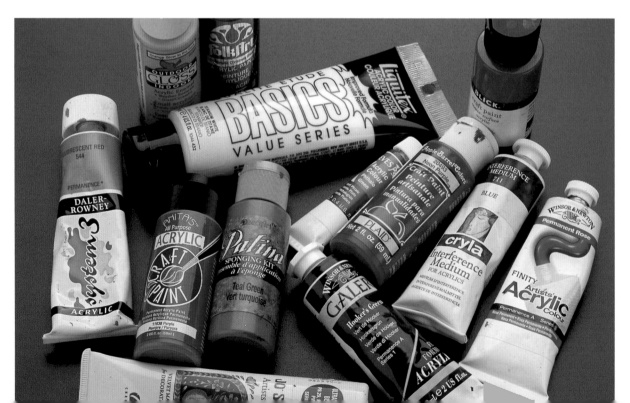

Three different acrylic paints with varying viscosity.

cost of pigments varies a great deal. For example, cadmium is relatively expensive, while iron oxide is relatively cheap, so that all the cadmium-bearing colors will be more expensive than the earth tones that rely on various forms of iron oxide for their color.

Viscosity

Acrylics come in either a fluid form or a thicker, more gel-like consistency. Craft paints are usually fluid, about the viscosity of heavy cream, while artist's acrylics, sold in tubes or widemouthed jars, are thick and creamy, like toothpaste. These latter are sometimes called "heavy-body" or "high-viscosity" acrylics. There is a lot of variation in viscosity among paints, and many manufacturers of artist's paints offer both fluid and heavy-body acrylics. Fluid acrylics of artist quality are similar to craft paints in their handling properties, but they have a greater pigment load. This means that the artist grade paint will retain more color intensity, per square unit of coverage, than the craft paint. To give a heavy-body acrylic paint a more fluid consistency, you can add matte, gloss, or glazing mediums and/or water (see "Acrylic Mediums" on page 20). However, while these mediums will reduce the viscosity of the paint, they also dilute the color, which you may or may not want. If you want to reduce viscosity without lessening color intensity, add flow release medium (page 21).

Paint viscosity affects the texture of its application. For example, a fluid paint works best to make an even wash of color, so either choose a fluid acrylic or add any of the mediums mentioned above to a more viscous paint. If you want to create a texture, choose a more viscous paint or mix fluid paint with a heavy gel medium (see page 20). It is this capacity for a range of consistencies that makes acrylic paints so versatile.

Drying Time

Straight out of the tube (or jar or bottle), acrylic paint dries fairly quickly. A medium coat of paint will be dry within minutes, not days, as is the case with some oil-based paints. This quick drying time can be an advantage if you are applying layers of paint that need to dry in between coats. I sometimes use a hair dryer to further speed up drying time.

For some techniques, such as combing or masking (see pages 63 and 66), you

This illustration shows the qualities of opacity and transparency of a variety of paints. The top half of each swatch is one application of paint; the bottom half shows an extra coat of paint.

may need to slow down the drying time. A retarder (see page 21) can be added to acrylic paint for this precise purpose. One part retarder to four or five parts paint is about the right amount; adding too much retarder will result in a surface that remains tacky for days. Glazing medium (page 21), in addition to its other properties, slows down the drying time of acrylic paint, and it can be added in as high a ratio as 1:1 without resulting in a tacky surface.

Transparency & Opacity

Acrylics can be opaque or transparent in varying degrees. The manufacturer's label will usually indicate whether a paint is opaque or transparent, but this designation should be considered relative. Any "opaque" paint will become transparent if spread thin enough, and by the same token a "transparent" paint will be opaque if applied thick enough.

Any acrylic paint can be made transparent by the addition of glazing medium, a transparent medium, or water. However, a transparent paint, or "glaze," applied over a white ground will produce a luminosity not possible with opaque paint. You can also use layers of transparent glazes to build up color on the paper rather than making the color you want by mixing it on the palette. This is a classic watercolor technique that works beautifully in acrylics. A transparent glaze can also be applied over a pattern to unify or tone down the color or to create the background color after a pattern has been established.

A transparent color of paint can be made more opaque by the addition of a good-quality white paint. A lesser quality white (one with less pigment) will lighten the color more than opacify it. If the original transparent paint has a high tinting strength, the color should change little with the addition of white.

This capacity of acrylic paints to be transparent or opaque is another quality that makes them so versatile, allowing an immense range of possibilities for making patterns.

Finish

Acrylic paints will dry to a glossy surface, a matte surface, or something in between, depending on their particular characteristics. Craft paints usually say on the label whether they are matte or gloss, but artist's paints often do not. As with viscosity and transparency, it is easy to

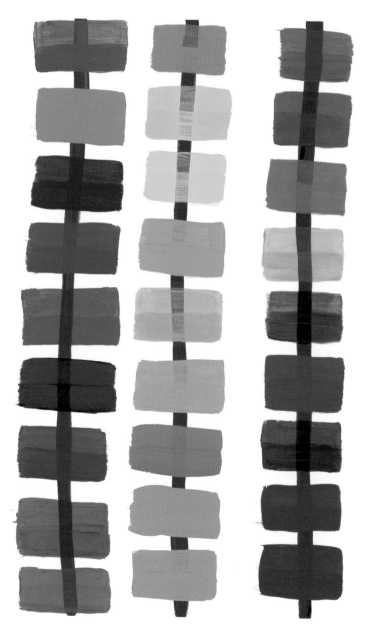

A variety of metallic and pearlescent paints painted on smooth printmaking paper.

The same interference paint from two different angles. These specialty paints can be used to great effect in creating patterns.

alter the finish, or surface quality, of an acrylic paint to suit your needs.

The addition of matte medium or gloss medium to a paint will decrease or increase its sheen, respectively, but will also dilute the paint and make it more transparent. A more effective way to alter the finish is to apply the matte or gloss medium over the paint once it has dried. Satin glazing medium mixed in with the paint will yield a satin finish. Glazing medium applied separately over the paint will leave the surface tacky, so it is best to mix it in with the paint. (See "Acrylic Mediums" on page 20.)

There are also metallic paints that imitate the surface of metals such as gold, silver, copper, and bronze. Pearlescent paints, with an iridescent finish, come in a wide range of colors. "Interference" paints are like metallics or pearlescents, but they change from one color to another depending on the angle at which they are viewed.

Lightfastness

The capacity of a paint to retain its color intensity under the exposure of light is called lightfastness. Most acrylics are reasonably lightfast and will retain their color for years without fading. However, the degree of permanence varies from color to color, depending on the pigments used, their concentration, and the medium in which they are suspended. Some manufacturers of artist's paints rate the lightfastness of each of their colors, but these ratings are not universal. The only acrylic paints you can be sure are not lightfast are fluorescent colors.

Acrylic Mediums

Acrylic mediums are additives that modify the characteristics of acrylic paint. They generally consist of colorless polymer acrylic emulsion—the vehicle for pigments in acrylic paint—plus modifiers that determine their sheen, opacity, viscosity, or drying time. I almost always add a little glazing medium or matte medium to paints with high pigment loads, just to make them stretch a little further and to improve their working consistency. I keep other acrylic mediums on hand for special techniques, such as those we will explore in chapter 3.

Matte Medium

Matte medium is used to dilute acrylic paint, adding more transparency while retaining some degree of its viscosity. As its name indicates, matte medium produces a matte finish. Matte medium can also be used on its own in various ways. It works as an adhesive for lightweight papers, as in the book page collage technique demonstrated in chapter 3 (see page 60). It can be used as a varnish or topcoat, like a decoupage medium. It can also be used to seal the surface of your paper before painting on it if you want a less absorbent surface. This is particularly applicable for sgraffito (page 58) and spritzing and blotting (page 54) techniques, which involve removing some of the paint to expose the white of the paper.

Gloss Medium

Gloss medium, sometimes labeled as gloss varnish, can be used in the same ways as matte medium, but it produces a gloss finish. It is even less absorbent than matte medium, so it works better as a sealant as well. I often use a mixture of matte and gloss mediums to create a satin-finish topcoat on projects such as three-dimensional collaged objects or on paper jewelry, both demonstrated in chapter 5.

Gel Medium

Gel medium has a high viscosity, about that of a heavy-body acrylic paint, and it is transparent. Gel medium is used to extend (or dilute) a heavy-body acrylic paint, making it into a transparent glaze while retaining its high viscosity. You can also add it to medium viscosity or fluid acrylic paints to give them more body. Gel medium, either gloss or matte, can be used to create textures, as demonstrated in chapter 3 (see page 68), and because it is transparent, the textures it creates have a unique depth and luminosity.

Modeling Paste

Modeling paste is very much like gel medium in its working qualities, but it is opaque rather than transparent. It is

A variety of acrylic mediums.

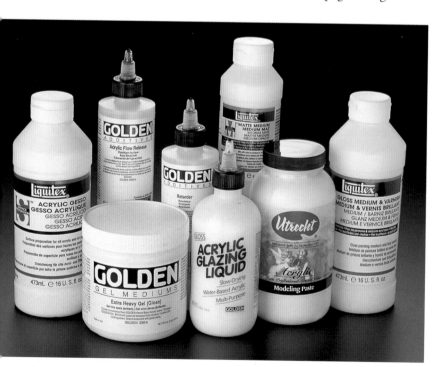

generally used to apply texture to a surface before painting it, which I do in the modeling paste texture technique in chapter 3 (see page 72). Although gesso can also be used for this technique, modeling paste has a higher viscosity and can hold textures more crisply.

Glazing Medium

Glazing medium is my all-purpose paint additive. It dilutes and extends the paint and gives it some transparency, and at the same time it slows down the drying time. It also has medium viscosity, like matte or gloss medium, which I find to be a good working consistency. Do not use glazing medium in a ratio greater than 1:1 with paint; otherwise the paint will not dry for a long time and the surface will remain tacky. If you want to further dilute the paint, extend it with matte or gloss medium, both of which have approximately the same drying properties as those of acrylic paint.

Retarder

Retarder extends the drying time of your paint while retaining its color intensity and opacity. Retarder is available as either a fluid medium or a gel, but as it is added in relatively small quantities, its viscosity does not make an appreciable difference. The manufacturer's label usually recommends the appropriate proportion of retarder to add to your paint, somewhere around 15 percent. As with glazing medium, if you add too much retarder the paint will remain tacky.

Flow Release

Flow release reduces the viscosity of a medium- to heavy-body acrylic paint. Adding water, matte or gloss medium, or glazing medium will help to make a heavy-body paint more fluid, but those mediums will also dilute the paint and make it more transparent. Flow release is added in relatively small quantities so that it does not dilute the paint much.

Gesso

Acrylic gesso contains essentially the same ingredients as those in white acrylic paint—acrylic polymer emulsion and titanium dioxide (the white pigment); but gesso is generally used as a primer to seal a surface before painting on it. You prime a canvas with gesso before painting on it with oils or acrylics in order to seal the surface so that the paint does not soak in. It is not necessary to prime paper before painting on it. However, you can use gesso to create interesting effects on paper (see, for example, the gesso resist technique on page 59).

The addition of a medium to paint affects the paint's sheen. From left to right: paint straight out of the tube, paint mixed with glazing medium, paint mixed with gloss medium, paint with gloss medium applied over it, paint mixed with matte medium, and paint with matte medium applied over it.

Watercolor

Acrylic and watercolor paints share many characteristics. One significant way in which watercolor differs from acrylic paint is that watercolor is resoluble in water once it is dry. That is to say, unlike acrylic, which is permanent when dry, watercolor can be lifted just by adding water and blotting. This characteristic of watercolor offers some technical possibilities not available with acrylics. On the other hand, it means that paper painted with watercolor is more vulnerable to damage from accidental spills or dirt because they cannot be easily wiped off. In chapter 3 I demonstrate several techniques that are particular to watercolor. These techniques can be used with both watercolor paints and dyes to varying effects.

A variety of watercolor paints and dyes.

Watercolor Paints

Watercolor paints are made from the same kinds of pigments as those in acrylic paints, but the pigments are suspended in a water-soluble binding medium rather than an acrylic polymer emulsion. This binding medium consists mainly of gum arabic, but it includes other ingredients that enhance the paint's working properties. Like acrylics, the price of watercolors is largely determined by the quality of the pigments used, and the pigment load. For the most part, you get what you pay for; the more expensive watercolors produce richer colors and can be diluted much further with water to produce pale colors. Watercolors come in pans (solid squares or disks of color, like those in the paint sets you used as a child) and tubes. Pans are useful for small-scale work and for transportability. However, for painting papers that will be used for collage, I recommend using tube colors because they are much easier to mix in larger quantities.

Watercolor Dyes

It is hard to achieve the same brilliance or intensity of color with watercolor paints as you can with acrylics. For this reason, I use watercolor dyes in addition to paints when I want particularly brilliant colors. Watercolor dyes, sometimes called "brilliant watercolors" or "concentrated watercolors," come in liquid form in small bottles with eyedropper applicators (Luma and Dr. Martin's are two common brands). To use watercolor dyes, transfer a little dye into a plastic cup and then dilute it with water in a ratio of about two parts dye to one part water. For even more brilliant color you can use the dye straight out of the bottle.

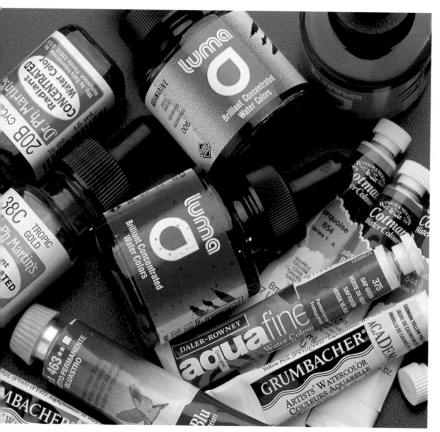

Adhesives can be categorized into two types: paste and glue. Pastes are generally made of plant starches, such as wheat starch or methyl cellulose. These are often used in bookbinding because they are archival and reversible—that is, you can wash them off if necessary. Glues are adhesives made from animal products or synthetics.

The most commonly available glues are made from synthetics. (I find synthetic glues to be the most appropriate and easiest to use adhesives for collage, but feel free to experiment with other glues and pastes.) Polyvinyl acetate (PVA) is available under many brand names—Elmer's, Sobo, and Aleene's are just a few—that vary only slightly in working properties. PVA dries clear and does not wash off. Generally, PVA is not archival, but it will last years before showing its age. Lineco and other companies catering to the bookbinding trade offer archival PVA. It is a little more expensive than Elmer's or Sobo, but if you are creating projects that you intend to pass on to the next generation, it is worth the extra expense.

Setting Up Your Work Area

It is important to have easy access to your art materials so that you can maximize your creative time and minimize time spent hunting for your paints and papers. If you don't have a room dedicated to creative work, keep your materials all together in a way that allows you to take them out and put them away easily. A drawer or cupboard or a storage container kept under the bed or on top of the fridge can work. Within this area, divide and organize your paints, adhesives, brushes, cutting tools, sponges, stamps, and other supplies in a way that makes sense to you. Cover your work area with newsprint or craft paper to facilitate cleanup.

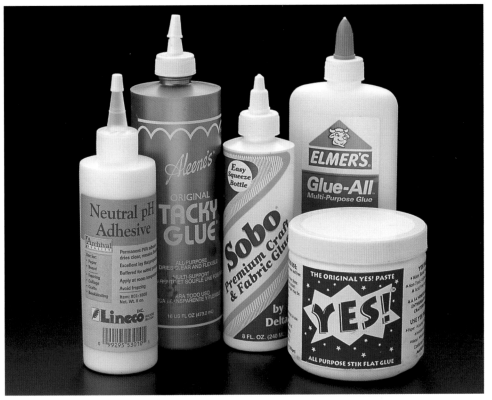

Some commonly available adhesives that are appropriate for collage.

Brushes

There are as many different kinds of brushes as there are uses for them. They come in many shapes, sizes, materials, and levels of quality. For some painting techniques it is preferable to have high-quality brushes, and they are worth the relatively high price. For creating decorative patterns on paper, however, less expensive brushes work well. I recommend getting a variety of flat and round brushes and any other brushes that appeal to you. These could include stencil brushes, ordinary sponge brushes from a hardware store, fan brushes, or any of the specialty decorative painting brushes now widely available in the paint departments of many hardware stores and in art and craft supply stores. Stiffer, coarse-bristled brushes will leave more pronounced brushstrokes, while finer, softer brushes are better for applying smooth, even coats of paint. Experiment with whichever brushes you choose and see how many different kinds of marks you can make. A good way to do this is to make a "sampler" as I have done here.

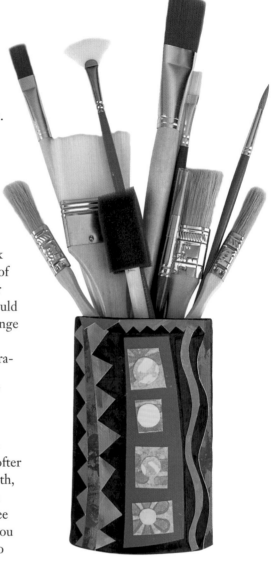

My collaged canister holds a variety of brushes.

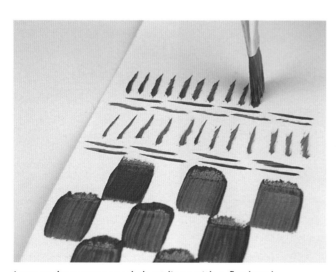

I can make squares and short lines with a flat brush.

I use a sponge brush as a stamp to make a series of irregular rectangles.

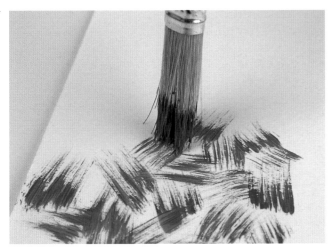

With a cheap hardware store bristle brush I make a pattern of wispy strokes.

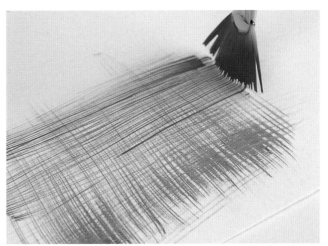

A fan brush can produce a crosshatched or woven textile kind of pattern.

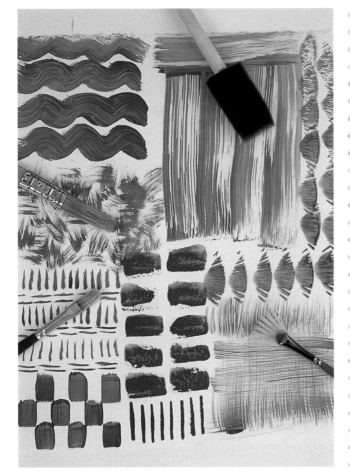

My finished brushstroke sampler.

Other Helpful Supplies

In addition to paper, paints, and the other materials described in detail in this chapter, there are a few useful tools and supplies you should have in your workbox.

I usually use a paper palette, which consists of a pad of impervious paper bound on two sides. When you are finished painting, you simply tear off the top sheet and you have another clean sheet ready to use. There are other types of palettes available, including white plastic palettes with separate wells for each color. A sheet of glass placed on top of a white surface makes a good palette, as does a white porcelain or plastic dinner plate.

Palette knives are essentially small metal spatulas with flexible blades. They come in a variety of shapes and sizes, any of which will work for the mixing and paint application techniques demonstrated in this book. Choose one that fits your hand and your budget comfortably.

An ordinary pair of sharp scissors should suffice for cutting out paper shapes for collage. A craft knife, however, is essential for cutting thicker materials, such as mat board, and it may make a cleaner job of cutting laminated papers or intricate shapes. Any kind of craft knife will work. I use an inexpensive pencil-shaped one with disposable blades, and I replace the blades often.

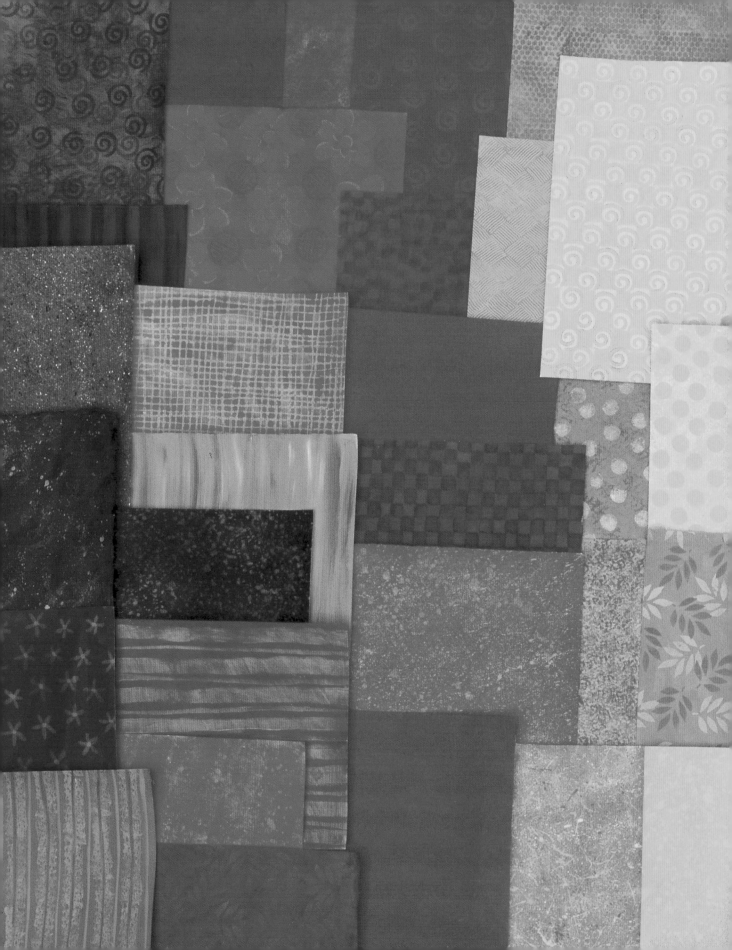

Understanding & Using Colors

In this chapter, I present the basics of color theory in order to make you more aware of your own personal reactions to color, and to establish a common vocabulary for talking about it. In making color choices, the main consideration should be what appeals to you. If some color or color combination doesn't look good to you, an understanding of how colors relate to one another can be useful in determining how to correct it. Likewise, if a collage composition is somehow not coming together, an analysis of color is a good place to start when making changes.

Hue

A color wheel made of patterned papers showing primary colors: red, blue, and yellow; secondary colors: orange, green, and violet; and tertiary colors: yellow-orange, red-orange, red-violet, blue-violet, blue-green, and yellow-green.

Any discussion of color theory will include the terms "hue," "value," "saturation," and "temperature." These are important concepts in that they are the means by which we can articulate and analyze our subjective perceptions of color. Hue is what we usually mean when we say "color." It is the characteristic of color that identifies it by name. "Red," "blue," "yellow-green," "blue-violet," and so on, refer to hue.

The Color Wheel

The color wheel, a device for illustrating relationships among colors, shows a spectrum of (theoretically) pure hues around its perimeter. For our own purposes we will refer to colors on the wheel as twelve distinct hues. However, by mixing different proportions of adjacent colors, you could create a color wheel with many more subdivisions than the traditional twelve.

PRIMARY COLORS are so called because they cannot be mixed from any other colors. They are the building blocks for all other colors. In theory, this is the case since we are speaking of hypothetical pure color; in practice, the actual pigments and mediums in which they are suspended can produce some variation in hue when mixed. Red, blue, and yellow are the three primary colors, and

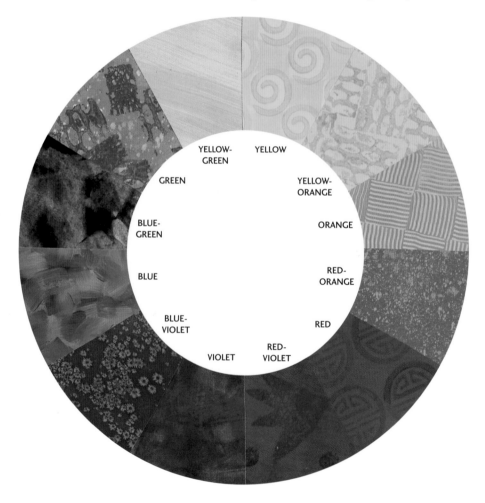

they are placed equidistant from each other on the color wheel.

SECONDARY COLORS are those mixed from two primaries: Green is mixed from yellow and blue; orange from yellow and red; violet from red and blue. Secondary colors are placed on the color wheel between the primaries from which they are mixed.

TERTIARY COLORS are those in between primaries and secondaries on the color wheel: Red-orange, blue-green, yellow-green, and so forth, are tertiary colors.

Complementary Colors

Complementary colors appear opposite each other on the color wheel. Red and green are complementary, as are blue and orange and yellow and violet. These complementary pairs each consist of a primary color and the secondary color mixed from the remaining two primaries. Tertiary colors also have complements: Red-violet and yellow-green, for example, form a complementary pair. Pairs of complementary colors have special properties that are important to your understanding of color mixing and the role of color in composition.

When a color is placed next to its complement, both colors tend to appear more intense, even to vibrate or clash. Because complementaries create this intense contrast, they are useful in creating interest in a composition. For example, adding some elements of green or turquoise to a collage that is primarily red and orange will create areas of interest or focus. However, complementary colors used in approximately equal measures can seem to compete with each other. Either of these options may be desirable.

In this collage, variations of red and green are used in approximately equal proportions. The complementary colors bounce off each other, creating a vibrant composition.

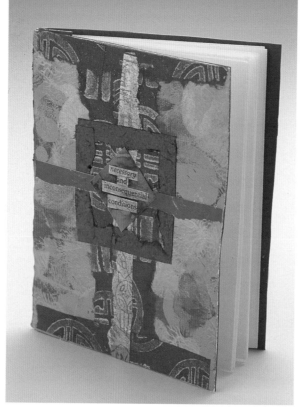

On this predominantly red and orange book cover, I placed complementary turquoise and green around the title to draw the eye.

Another important property of complementary colors is that mixing a pair of them in approximately equal amounts produces a dull brown, or "mud" color. This is useful to know for two reasons. First, to achieve fresh and bright colors, it is a good idea to avoid mixing complementaries. On the other hand, you can decrease the intensity of a color, or "neutralize" it, by mixing it with a small amount of its complement. For example, to neutralize a bright orange, you can add a tiny bit of blue. You can achieve an interesting range of browns and neutrals by mixing complementary colors in varying proportions. However, you may want to include a few browns and neutrals in your palette of paints in addition to mixing them from primaries and secondaries. Unbleached titanium (off-white), raw umber, burnt sienna, sepia, and medium gray are good choices.

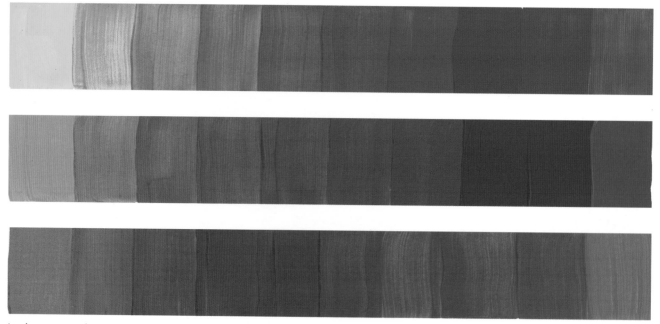

In these examples, I mixed pairs of complementary colors in gradated proportions. As you can see, mixing a color with a little bit of its complement slightly dulls it, while adding more eventually creates a neutral color.

Analogous Colors

Analogous colors are those that are near each other on the color wheel. Red and orange, for example, are analogous, and so are red and red-orange. "Analogous" is a matter of degree. Red and yellow-orange could be considered analogous, but a slightly bluish red, tending toward red-violet, would not be considered analogous with yellow-orange. In practice, analogous colors will almost always blend harmoniously in a color scheme. If you are unsure about choosing colors for a composition, begin with a few analogous colors. You can always add bits of contrasting colors from the opposite side of the color wheel to add visual interest.

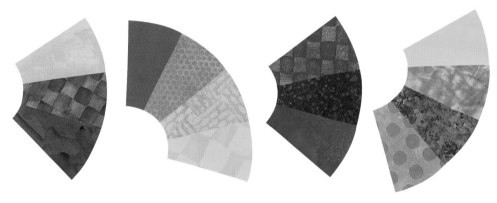

Groups of analogous colors I made from my patterned papers. Any of these color groupings would make a harmonious palette for a collage.

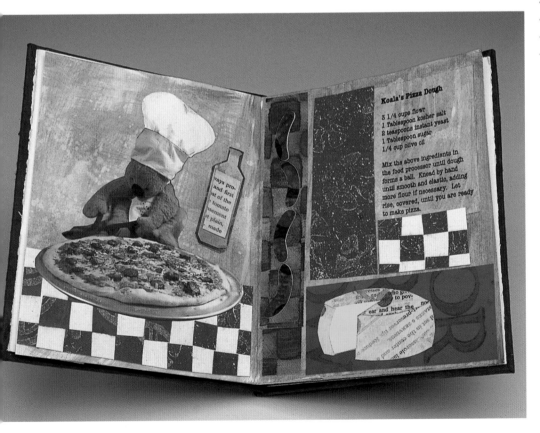

Orange

Orange is usually associated with fire and the sun. Warm yellow-orange can be friendly and inviting, while hot red-orange may evoke a sense of danger. Saturated orange will dominate a composition unless it is balanced by other strong colors, or used sparingly. Tints and shades allow orange to relax into a less dominant role, from peach, salmon, coral, and sand on one end of the spectrum, to terra-cotta, burnt sienna, and other earth tones on the other.

I used mostly analogous oranges, reds, and yellows to create this altered book collage. Small accents of contrasting green break up the monotony.

Value

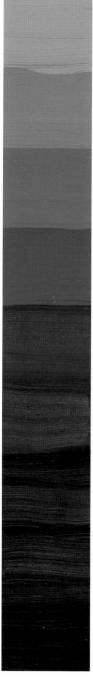

Value (sometimes called tone) refers to the relative lightness or darkness of a color. Adding white to a color produces lighter values, or "tints," while adding black produces darker values, or "shades," as the value scale to the left illustrates. In practice, you may want to change the value of a color by adding a lighter or darker color rather than white or black. For example, you can make a medium blue darker by adding some deep blue such as ultramarine, or by adding dark green or dark purple. By the same token, you can lighten an orange by adding light yellow rather than white. The addition of other colors will change the hue as well as the value of the original color in a different way than adding black or white will. By using colors other than black or white to alter lightness or darkness, you will retain more of the original color's intensity (see "Saturation" on page 34).

It is useful to make value scales using black and white to see how a particular color is altered in value, hue, and intensity. To make a value scale, start by applying a square of an unmixed paint color to what

Papers painted with a range of values. Using several tints or shades of a single color when painting papers for collage can make the collage elements more interesting than if you use just one color.

Starting with a pure color in the middle, I created this value scale by adding white on one side and black on the other in increasing amounts.

In these examples I've changed the value of a color by mixing it with another color rather than black or white. The blue was darkened with violet and the orange was lightened with the addition of yellow.

will be the middle of the value sequence. Add a small amount of white to your paint on the palette, mix it thoroughly, and paint another square in the resulting tint. Add a little more white, mix, and paint another square, and so forth. To create shades, start with a fresh dab of pure paint, and add small amounts of black paint in a similar sequential fashion. Making shades usually calls for adding much less black than the amounts of white you add to make tints, so start with a very small amount. The amount of white or black you need to add to a pure color to create

tints and shades depends largely on the tinting strength (which depends on the pigment load) of the particular paints you choose. You will need to add much more white, for example, to a heavily pigmented paint than to a craft or economy paint to create the same tint. By the same token, if your black paint has a high pigment load, you will need to add smaller amounts of it to produce shades than if it has a low pigment load. It is actually easier to produce a desired shade if you use an inexpensive black paint with a low pigment load.

These colorful peppers were made by using patterned papers of the same hue but different values. You can create depth and form in your collages by using several values to represent shadows and highlights.

Saturation

Saturation refers to the relative intensity, or brightness, of a color. You probably noticed in creating value scales that the addition of black or white to a color not only changes the color's value but also its intensity. When you add to a color a small amount of its complement, you also decrease its saturation, making it less bright.

You can design dynamic compositions by using a range of saturated and unsaturated colors. Placing saturated and unsaturated colors near each other creates contrast: A more saturated color will stand out against a less saturated one.

When painting an individual paper you can use one color in various degrees of saturation. For example, here I used a bright saturated green, added a tiny bit of red to the same green to produce a slightly olive green, and then added a little bit of black for a darker shade of the same color.

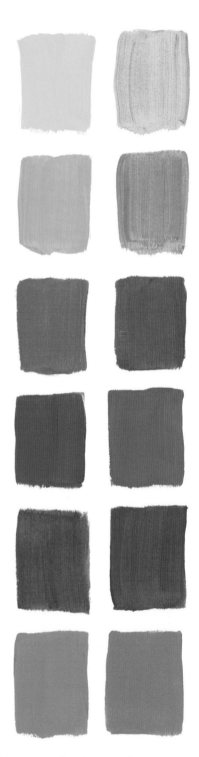

In these swatches I toned down each of the six primary and secondary colors (left) by adding a bit of its complement (right).

Colors are said to be warm or cool depending on the mood they evoke. Warm colors are those often associated with the sun or fire, such as red, orange, and yellow. Cool colors, such as blue, green, and violet, are those associated with the ocean. However, you can describe a reddish violet as a warm violet, or a yellowish green as a warm green. A warm red is one that tends toward orange, while a cool red is one that tends toward magenta. Whether a color is considered warm or cool is somewhat subjective, depending largely on the quality of the colors around it. You can incorporate subtle contrast into your patterns by using warm and cool versions of the same color.

When putting together a collage, keep in mind that, in general, warm colors tend to move forward while cool colors recede. This concept is sometimes referred to as "push and pull."

Warm (left) and cool (right) versions of a range of hues.

BELOW: Notice how in this necklace and earrings set I made from bits of patterned papers (see page 117 for instructions on making jewelry), the warmer orange colors pull forward, commanding the most attention, while the cooler turquoise recedes.

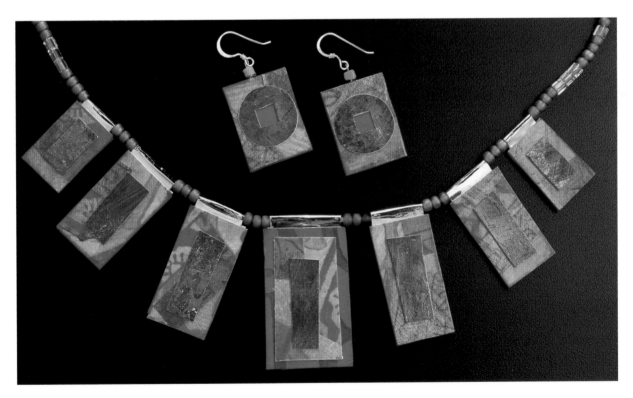

Color in Context

COLOR & MEANING
Blue

Blue is a color of vast expanses, of oceans and sky, making it a calm and universal, sometimes spiritual color. Water is among blue's strongest associations, from the aquamarine of hot springs and tropical waters to the deep indigo of northern lakes and cold oceans. Blue is also associated with melancholy or sadness—the blues, as it were.

I hope it is clear from this discussion of color theory that colors are related to one another in particular ways. You may be able to describe an individual color in terms of its hue, value, saturation, and temperature or mood, but these characteristics become much more apparent, and more meaningful, when you place that color in the context of a collage or pattern. We will further discuss the role of color in composition in chapter 4, but for now let's take a look at how individual colors affect each other.

Contrast

In creating individual decorated papers to use in collage, patterns made from several closely related colors—analogous colors, three or more different values of one color, or saturated and unsaturated versions of the same color—are much more interesting than those made from just solid colors. However, a collage consisting of only closely related colors may seem boring. Contrast is important for setting one element in your collage apart from another. You can use contrast of hue, value, saturation, or color temperature to achieve this effect. Colors farther apart on the color wheel will contrast more than those close to each other. As discussed in "Complementary Colors" (page 29), colors opposite each other on the color wheel produce a very strong contrast of hue. Generally speaking, a highly saturated color will also stand out in contrast to a less saturated one. This is where neutrals, tints, and shades become important. Neutrals, tints, and shades, are, by definition, less saturated than purer hues.

Neutrals

Neutrals are colors that tend toward beige or gray. Browns, earth tones, taupe, sand, buff, and so forth, are considered neutrals. Mixing a color on the color wheel with its complement will result in some version of brown.

As discussed under "Saturation" (page 34), mixing any hue on the color wheel with just a small amount of its complement will neutralize it. For example green mixed with a tiny bit of red will still be green, but it will be toned down. This is useful to know if you have so many bright colors in a composition that they are competing with each other and your image is getting lost in the background. Using slightly neutralized colors in the background will set off the bright colors of the image.

As you can see in these examples, green contrasts more with red (its complement) than with blue, which is close to green on the color wheel. Likewise, green contrasts more with blue than with blue-green, which is even closer to green.

A variety of neutrals. Some were painted with neutral paint colors (e.g., burnt sienna), while others were made by mixing pure hues together and adding white or black, or both.

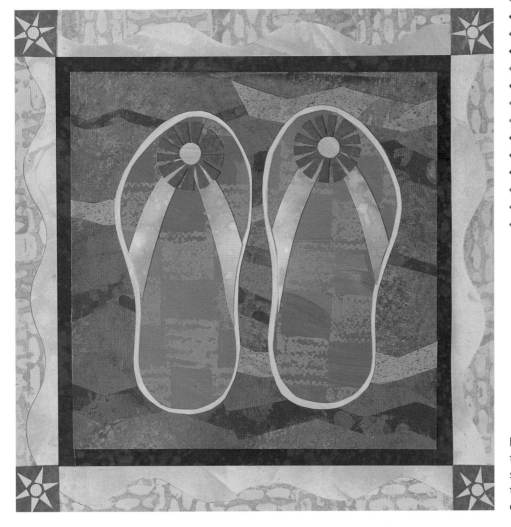

In this whimsical composition, the sandals stand out so clearly in part because the background is composed of neutral colors.

CHAPTER 3

Making Patterned Papers

I like to get started making collages by creating a whole spectrum of patterned papers. Painting patterned papers, even before making collages with them, is an ideal way to stimulate your imagination. It demands no special artistic skill, and yet returns so much in terms of creative satisfaction. In this chapter we will explore many techniques for creating patterned papers in acrylics and watercolor. The techniques demonstrated in this chapter are merely a sampling of the many possible approaches to making patterns. You will no doubt discover your own.

Pattern

Pattern is an overall design consisting of a repeating motif. The motif can be anything from a simple brushstroke or sponge mark to a complex stenciled or stamped image. It can be repeated in a random-looking "tossed" manner, in a carefully measured grid, in rows, or in any other way that you can think of. All of the techniques discussed in this chapter are particularly well suited to creating pattern.

Layering Patterns

Patterns need not be limited to the repetition of a single element. Layering elements is a fun way to make patterns. The result can be as simple or as complex as you like. The examples below appear to be simple, but note that the bee is stamped over a background consisting of a subtle sponged pattern. Most of the papers I create for collage consist of more than one element, or the

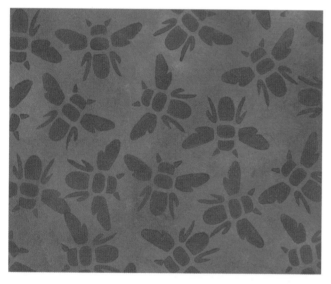

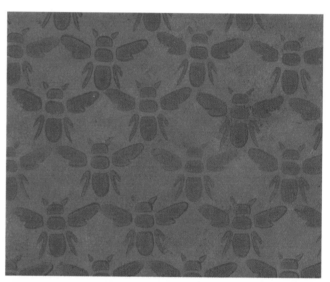

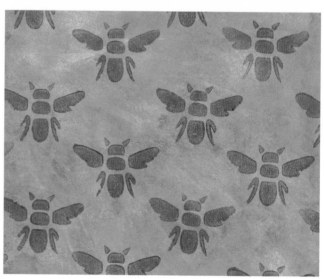

A few examples of various types of pattern organization made with a bee stamp.

same element repeated in two or three different colors. Layering is a great way to create subtle complexity in your collages, and it is no more difficult than using a single, repeated motif.

Texture

For our purposes, visual texture can be considered a type of pattern. Many techniques demonstrated in this chapter, such as sponging, spattering, and palette knife application, show textures that, while not conforming to the motif-on-background model, certainly exemplify overall designs. We will also explore some specific techniques for creating physically textured papers.

Coverage

Coverage, in the language of pattern, refers to how much of the background is covered by the motif. You can think of coverage as pattern density. In making collages, you will want to have papers with a range of pattern coverage. For large pieces, sparse coverage may be appropriate, while you will likely want to cut smaller elements from papers with denser coverage. This is not a hard-and-fast rule, but rather a guideline.

Scale

One way to add interest to your pattern is to vary the scale of the elements. You may start with a very small pattern, such as a sponged texture, and then add a larger stamped design. Or, if your pattern consists of a relatively large repeated motif, you may want to add a smaller element, such as a spattering of a contrasting color. In addition to varying the scale of elements within a patterned paper, using a variety of pattern scales in a single collage project can be very effective in creating dynamic compositions.

Using a selection of patterned papers with varying coverage and scale adds visual interest to this simple composition.

Background Colors

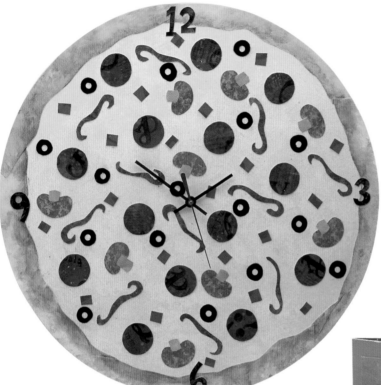

Most of the techniques in this chapter are demonstrated on a background that has already been painted in a base color, so I'll begin by demonstrating a few techniques for laying down a background color. These include sponging, creating a wet-in-wet wash, and using a palette knife application. Because we will be creating patterns and textures over the background, it is not necessary to achieve a uniform layer of paint. The textures and variations resulting from these applications will add character to the finished pattern.

The face of this whimsical clock is covered in paper that has simply been sponge-painted. The papers used for the "pepperoni" and "mushrooms" have patterns painted on their colored backgrounds.

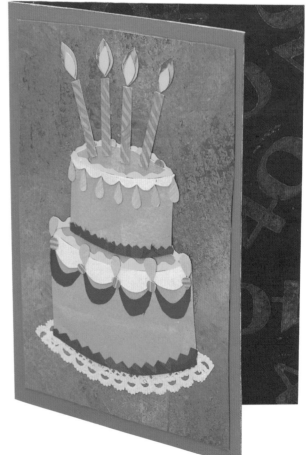

Several of the papers used in this birthday card were left unpatterned. The marks of the sponge used to paint the blue paper are almost a pattern in themselves.

sponging

Wiping your sheet of paper all over with a paint-soaked sponge is a fast and easy way to create a background color for further paint application. To prepare my surface for painting, I first soak a sponge in clean water and wipe the paper thoroughly to get it damp; this facilitates a smooth application of paint. You can sponge on a simple background in one color, or add several sponged layers for variety.

Step-by-Step Technique: SPONGING

1 First I mix a yellow-green paint on the palette and add some glazing medium. Having dampened the paper with a wet sponge, I dip the sponge in paint from the palette and wipe it more or less evenly over the paper.

2 Next I sponge on a darker green in a repeated pattern.

3 To add more variation, I mix a yellower yellow-green and sponge that on in between the areas of darker green. I add some of the original background color to the edges to soften them.

palette knife application

Another method of getting color onto a large surface quickly is to apply paint with a palette knife. This method creates a distinctive texture, which you can accentuate for effect, or else smooth out with a fine sponge as you go. As with the sponging method, you can leave your paper with one layer of paint or apply additional layers of paint using the palette knife or any other technique. In the following demonstration I apply green-gold paint using this technique.

Step-by-Step Technique: PALETTE KNIFE APPLICATION

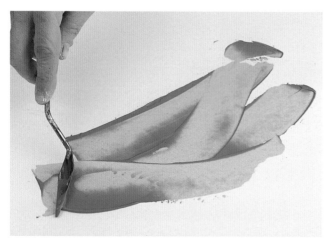

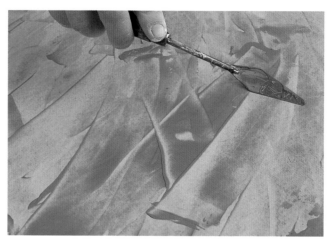

1 I first mix my paint with a little glazing medium, and then scrape it onto the paper with a palette knife. I cover the whole paper, spreading the paint thin.

2 Next I add another layer of paint, this time developing the texture. The finished paper is shown below.

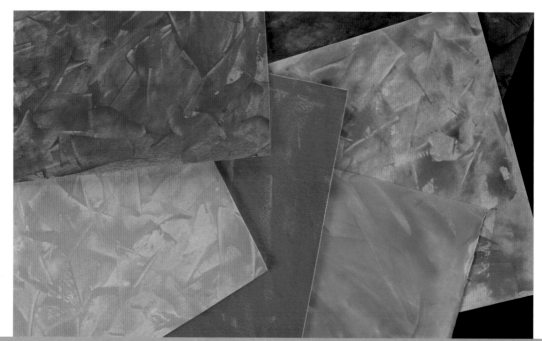

Several backgrounds applied with a palette knife.

wet-in-wet wash

To create a more or less even wash of color, start by applying plain water to the entire surface of the paper. You can use a brush, a sponge, or a sponge brush. The paper should be damp, not soaking wet. If it is too wet you can blot it with paper towels or let it sit until some of the water is absorbed. This allows the paint to spread evenly over the paper. Again, a perfectly even paint application is not the goal—it's OK if there are brushstrokes or sponge marks showing.

Step-by-Step Technique: WET-IN-WET WASH

1 To make acrylic paint into a wash, I put some paint and some water onto my palette.

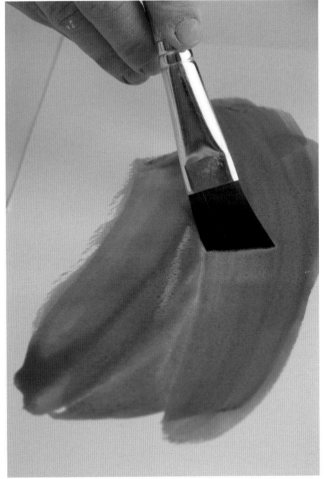

3 I then apply the diluted paint onto the wet paper in broad even strokes. Bear in mind that since I will be cutting the papers into pieces for collage, an absolutely even application is not that important.

2 Next I mix the paint into the water a little at a time with my brush.

Creating Patterns with Acrylics

With a few easily obtained tools and some inexpensive paint, you can create a vast array of decorative papers—whether or not you have ever drawn or painted before or feel you have any particular artistic talent. In this section we will explore a wide variety of tools and techniques for making patterns. The techniques are all perfectly accessible to the novice and can also expand the repertoire of the experienced artist. Brushes, sponges, stamps, and stencils are just a few of the decorative painting tools we will use with acrylic paints.

A variety of painted patterns made with stamping and spattering techniques.

I decorated this paper wallet using a number of patterned papers. The flap is covered with a pattern made by spritzing and blotting several shades of purple (see page 54). The base of the wallet was painted with a palette knife application, and the decorations are made from assorted scraps.

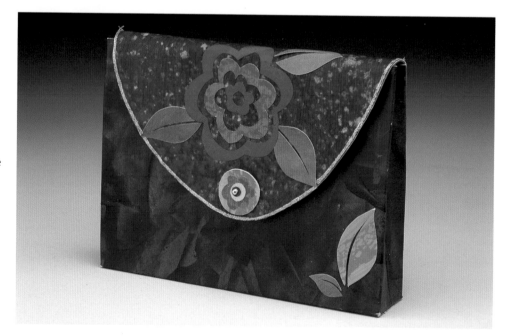

spattering

Spattering is a good way to add interest to an already established pattern. A little spattering of gold or a high-contrast color can make a pattern really sparkle. Spattering by itself can also make an interesting pattern if you spatter several colors of paint onto a background. I find it very effective, when creating a spattered pattern, to use two or more colors closely related to the background color, and then one high-contrast color. Black, white, fluorescent, and metallic colors work well for this final application, as does a color that is complementary to the background color. You can use a toothbrush or other stiff-bristled brush to apply the paint.

Several papers with a spattered pattern.

Step-by-Step Technique: SPATTERING

1 I dip the ends of the bristles in orange paint that has been mixed with a little medium and water so that it is fluid but not watery. Holding the brush at an angle close to the paper, which has been painted red, I draw my thumb over the bristles so the paint spatters over the paper. I repeat this motion, moving the paper around as I go and changing the angle at which I hold the brush.

2 Next I apply yellow paint in the same manner.

3 The final application of dark green adds depth and contrast.

stenciling

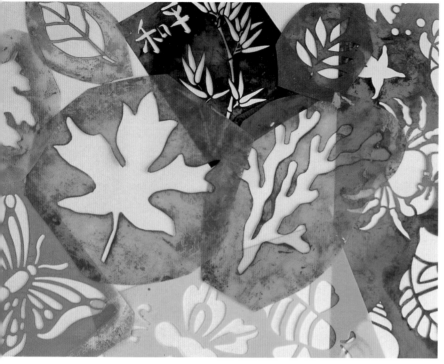

An assortment of commercial and homemade stencils.

Stenciling lends itself well to creating patterns. It is a good way to make intricate images that would otherwise be very time-consuming to paint freehand. You can buy commercially made stencils from art and craft supply stores. They are available in a huge variety of motifs and sizes. You can also cut your own stencils using stencil vinyl, also available at art and craft supply stores. First draw your stencil design on paper, then trace it onto the transparent vinyl with a fine-point permanent marker. I usually insert a new blade into my craft knife before cutting a stencil, as this makes it much easier to cut intricate shapes, sharp corners, and smooth curves.

To apply paint over a stencil, you can use a stencil brush, a sponge brush, or a sponge. I prefer a sponge or a sponge brush because I find it easier to control the amount of paint I am applying.

Step-by-Step Technique: STENCILING

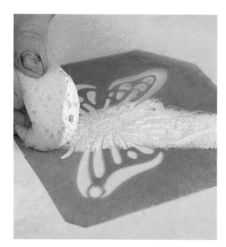

1 I lay a commercially made butterfly stencil over my paper, to which I've already applied a yellow sponged background. Using a synthetic sponge, I apply white paint on top of the stencil.

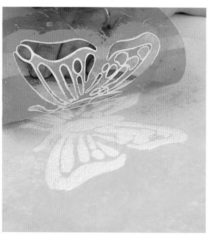

2 I remove the stencil to reveal the butterfly.

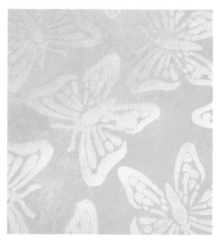

The finished butterfly pattern.

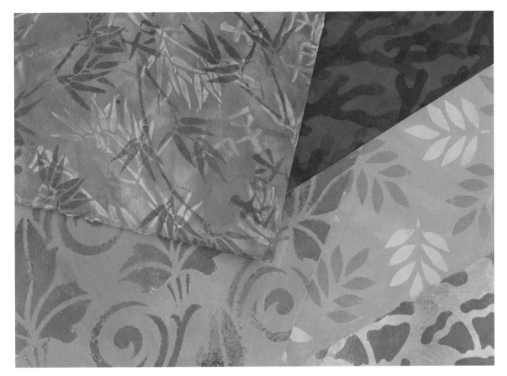

These patterns have all been created using the stenciling technique. The green pattern combines stenciling with the gesso resist technique (the lighter motif) demonstrated on page 59, with a darker green stenciled over the resulting pattern. For the orange pattern I used the same stencil in two different values of one color: one that is darker than the background and one that is lighter. For the plum-colored pattern I used transparent plum paint, layering the stenciled motif.

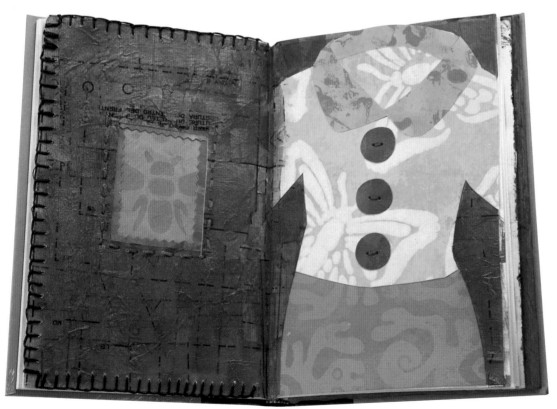

For the blouse on this altered book page, I used the yellow butterfly stenciled paper I made in the above demonstration.

sponge stamping

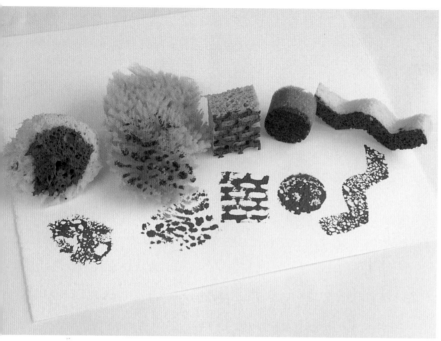

Natural "silk" and "wool" sponges, and three synthetic sponges cut into various shapes.

We have already used a sponge to apply an initial background color; here we are using the sponge's texture as a pattern motif. There are many varieties of sponges made for decorative painting, and household cellulose sponges can produce interesting effects as well. There are natural sponges and synthetic sponges to choose from. Natural sponges, such as "silk," "elephant ear," and "wool" sponges, have an inconsistent texture, making it possible to produce varied effects. Wool sponges have an open, coarse structure and produce an open texture, while silk and elephant ear sponges have a more compact structure and can be used for finer textures. Synthetic sponges, usually made of polyester or cellulose, have a more consistent, or even stylized texture. Compressed sponges, which expand once they are submerged in water, are very easy to cut into shapes.

Step-by-Step Technique: STAMPING WITH A NATURAL SPONGE

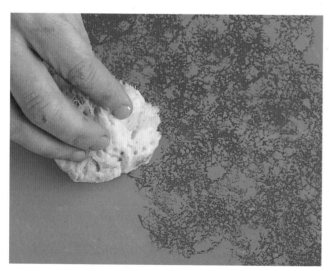

1 On a light purple background I create an overall texture in darker purple using a natural open-structured sponge.

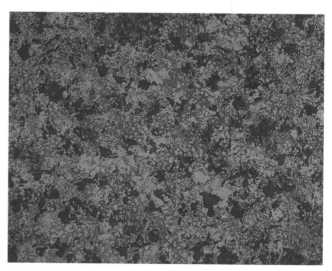

2 Once the first application is dry, I use a different coarse-textured sponge to apply a bright reddish purple.

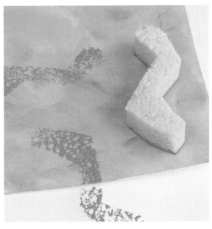

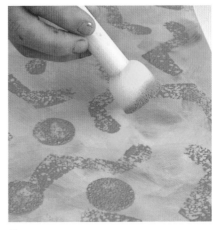

1 I cut a zigzag shape from a compressed sponge, then reconstitute it in water.

2 I begin making a random pattern using this zigzag as a motif.

3 I then use a metallic green to add another pattern element with a round sponge brush.

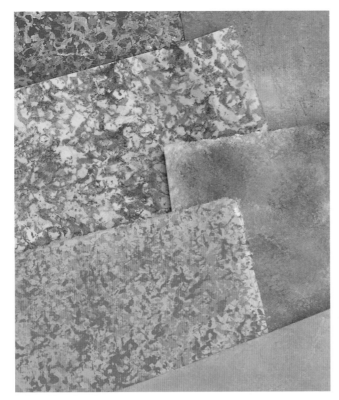

Different textures made with natural sponges. The textures on the left were made with coarse natural sponges, while the ones on the right were made with fine natural sponges.

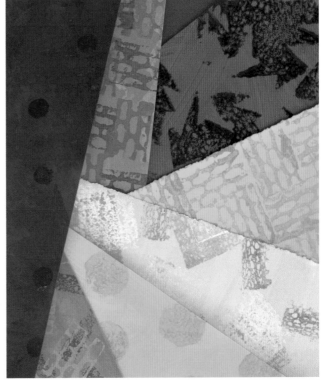

A variety of patterns made by stamping with synthetic sponges.

brushstrokes

One of the easiest ways to create a pattern is by applying simple brushstrokes. You can create an infinite variety of patterns in this way. In the following demonstrations I use a flat nylon brush to make a random pattern of three different yellows, a stencil brush to make a pattern of dots on a deep pink background, and a flat, stiff-bristled brush to make a swirl pattern. (See "Brushes" on page 24 for examples of some other possible brushstrokes.)

Step-by-Step Technique: RANDOM BRUSHSTROKES

1 First I make a random, "tossed" pattern of short brushstrokes in a yellow that is lighter than the background color.

2 Next I do the same with a darker yellow-ochre. I then blend the colors slightly with brushstrokes in the original background color.

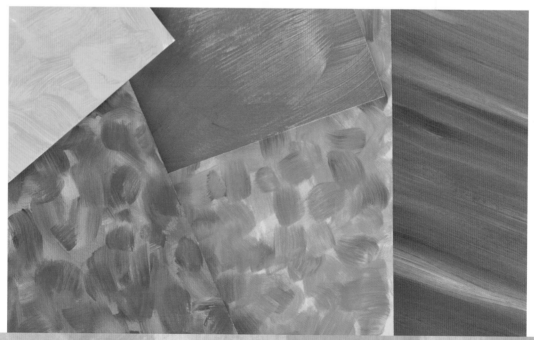

A variety of patterns made with simple brushstrokes.

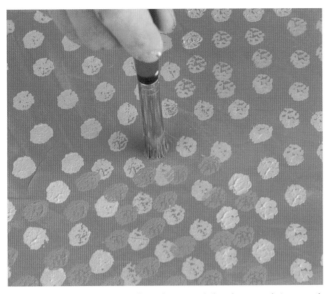

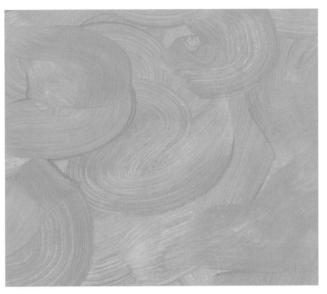

In this example I start with a deep pink background (created with the palette knife technique described on page 44) and apply random dots in light pink with a stencil brush. With the same brush, I create another pattern of random dots, this time in a light periwinkle.

After mixing enough glazing medium into my paint to make it transparent, I make swirling motions with my brush to create an overall pattern. Notice how, because the paint is transparent, the white of the paper shows through.

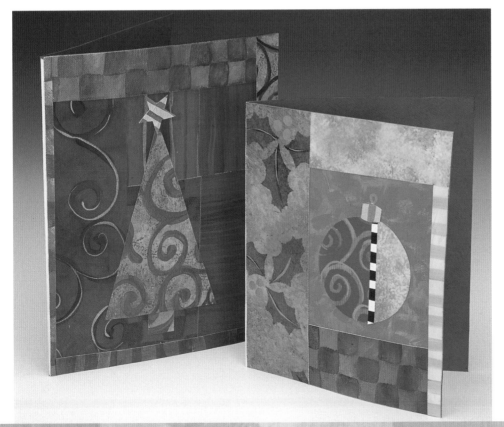

For these Christmas cards (see page 98 for instructions on making cards) I used several papers that had been painted with simple brushstrokes, such as lines, checks, and swirls.

spritzing & blotting

Some papers painted with the spritzing and blotting technique.

Spritzing and blotting is a process of applying water with a spray bottle to a layer of paint that is not quite dry, and then lifting, or blotting, the area with a paper towel to remove some of the paint. This leaves a lighter pattern of water droplets. The amount of paint that lifts off depends on a couple of factors. First, the absorbency of the paper will affect how much of the initial application of paint remains on the paper. In the demonstration I begin with paper to which I have applied a coat of matte medium. This seals the surface of the paper so that it absorbs very little paint. The other factor affecting the pattern's contrast is how long you let the water sit on the paper before blotting. To the extent the paper allows, the longer the water sits, the more paint it will dissolve.

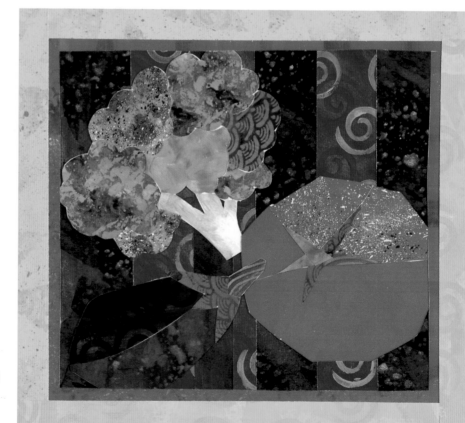

Mixed Veggies uses several papers that have been painted with the spritzing and blotting technique.

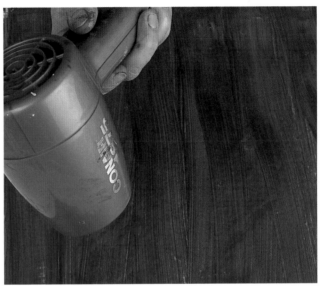

1 Starting with a sheet of paper to which I have applied a coat of matte medium, I brush on a dark purple paint. When the paint is partly dry—to the tacky stage—I spritz water onto it with an ordinary household spray bottle.

2 I use a hairdryer to dry the paint further, but let the water droplets remain wet.

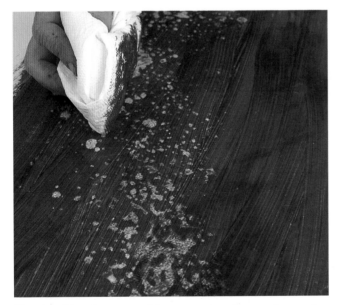

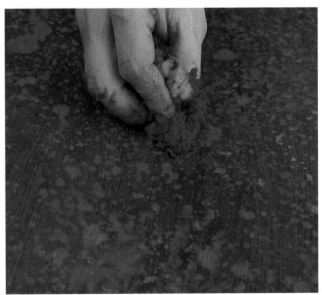

3 I then blot the water with a paper towel, removing some of the paint. You can leave the paper as is or repeat the same technique with a different color.

4 When the dark purple is thoroughly dry, I use a sponge to apply a transparent deep magenta and proceed with the same technique. Using a transparent paint helps to achieve more depth and texture.

drip transfer

This interesting technique involves dripping or splattering (or flinging) paint onto a sheet of waxed paper, and then transferring it onto your background paper. The resulting pattern will have the effect of a repeated design because you repeat the transfer procedure several times while changing the orientation of the waxed paper.

You can start with blank white paper or apply a background color with any of the methods described earlier in this chapter. Use a sheet of waxed paper that is approximately the size of the paper. Choose two or more colors for your pattern and mix them each to a fluid consistency, about that of heavy cream. To fling the paint, you can use either a brush or a palette knife. However you choose to apply the paint, work quickly so that the paint does not dry before you transfer it to your paper.

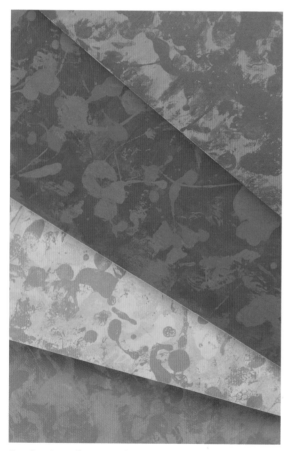

A selection of papers decorated with the drip transfer technique.

RIGHT: These ornaments were constructed by sandwiching paper around wire, tassels, and hanging cords (see instructions on page 114). I used a variety of patterned papers, including small pieces of paper I painted with the drip transfer technique.

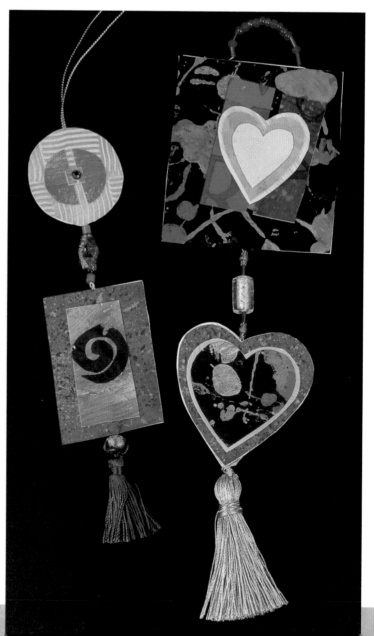

Step-by-Step Technique: DRIP TRANSFER

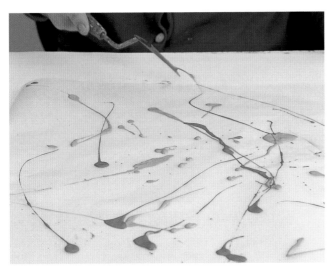

1 Using a palette knife, I fling paint onto the waxed paper. In this example I am using three different colors.

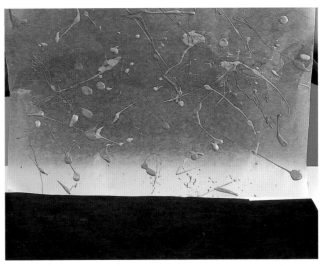

2 I pick up the waxed paper and get ready to position it paint side down on my black background paper. I press lightly but evenly over the paper to transfer the paint without squishing it more than necessary.

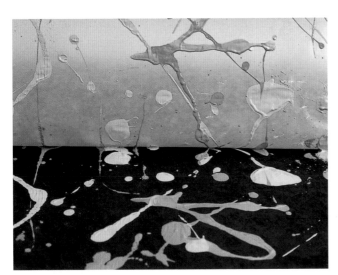

3 After the first transfer, I carefully lift up the waxed paper to remove it.

4 I turn the waxed paper 180 degrees and repeat steps 2 and 3 to get my final pattern. I could stop here or turn the waxed paper 90 degrees to make another tranfer, or even transfer just part of the pattern.

sgraffito

Sgraffito, in this context, refers to the technique of scratching through a surface layer of paint to expose the white (or other color) paper beneath. Any pointed instrument with a rounded end will work as a sgraffito tool. In the following demonstration I use the end of a paintbrush. Knitting needles, chopsticks, and wooden matches are a few other tools that will work just as well. If you are using sgraffito on a white background, as I do in the demonstration, it is a good idea first to apply a coat of acrylic matte medium to seal the paper; be sure to let it dry completely before applying color. This ensures that the sgraffito lines will be distinct, as the paper will not absorb the paint on top. If you are using sgraffito over a colored ground, your first coat of paint will seal the paper adequately.

Step-by-Step Technique: SGRAFFITO

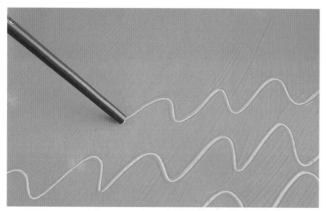

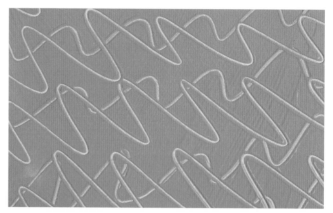

1 I begin by painting my paper, which I have coated with matte medium, a bright orange. While the paint is still wet, I make a pattern of wavy stripes using the end of a paintbrush. Mixing the paint with glazing medium or retarder will slow its drying time.

2 Over the first set of waves, I make a second series going in the opposite direction.

Here are some examples of sgraffito over colored grounds.

gesso resist

Gesso resist is a fun and easy technique for creating a tone-on-tone effect. It is a great way to add interest to an otherwise monochromatic paper. Here is how it works. Where gesso is applied to paper, because the paper is absorbent and the gesso is not, the subsequent application of paint will be resisted rather than absorbed, creating areas of lighter color. Where the paper is left exposed, it absorbs more of the paint, creating darker areas. You can enhance this effect by wiping the surface gently with a paper towel immediately after applying the paint.

You can apply the gesso using any of the tools and techniques described in this chapter. My favorites are brushing, stamping, and stenciling. Here are a number of patterns made using the gesso resist technique.

Step-by-Step Technique: GESSO RESIST

1 First I brush on a striped pattern with the gesso.

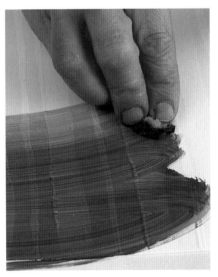

2 After the gesso has dried completely, I use a sponge to apply blue paint that has been mixed with glazing medium to make it more transparent.

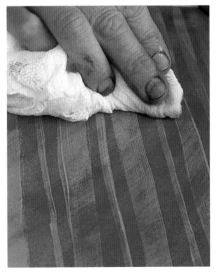

3 While the paint is still wet I wipe the surface lightly with a paper towel to enhance the striped pattern.

book page collage & letter stamps

These earrings were made with scraps of patterned papers, including bits of papers made with the book page collage technique. (See page 117 for instructions on making jewelry.)

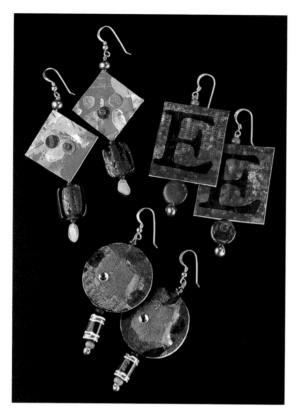

This technique uses letters, words, and type as pattern motifs. Any bits of torn or cut paper and any kind of stamp can be used in this technique, provided they are relatively lightweight. I like the way the stamped letters and book pages look together, the scale of the large letters against small type, and the potential for content beyond the purely visual.

If you don't have books on your own shelves that you could commit to this fate, get a few at a secondhand shop or a library sale. One book will suffice, but several different books can make for a more interesting pattern. Try to find two or three books with distinct typefaces as well as other differing visual characteristics.

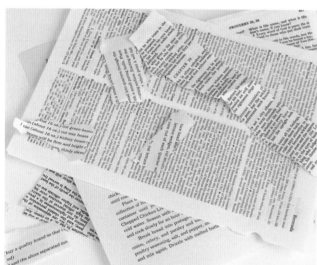

For the following demonstration I'm using pages from a cookbook, a geographical encyclopedia, and a Bible, all water-damaged and bought for practically nothing at a library sale.

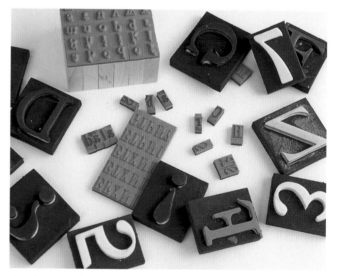

A selection of letter and number stamps in different sizes and materials.

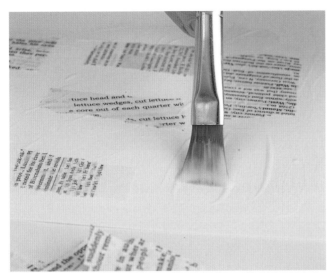

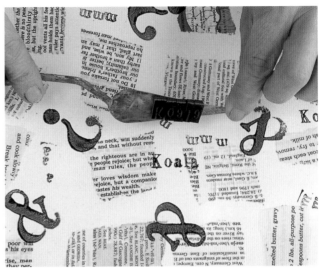

1 First I tear or cut the book pages into the shapes I want for my pattern motif. Next I apply matte medium to the paper, making sure the entire paper is coated, and place the torn shapes. I orient some of the type vertically and some horizontally. I then brush matte medium over the shapes.

2 Once the medium is dry, I randomly stamp letters, numbers, and symbols all over the page using acrylic paint, which I apply to the stamps with a fine sponge. For fun I use my palette knife and magnetic letter stamps to make the word "koala."

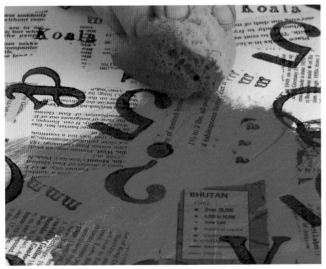

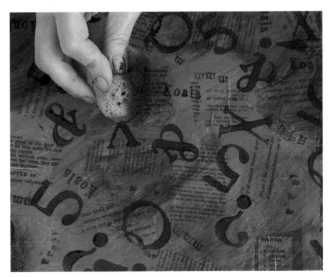

3 I apply a transparent glaze of magenta paint with a sponge (a brush will also work). I selectively wipe away areas of wet paint to emphasize the text underneath. Once the magenta has dried to a tacky state, I apply a glaze of quinacridone gold.

4 I sponge on sepia in select areas.

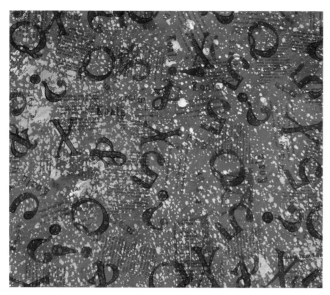

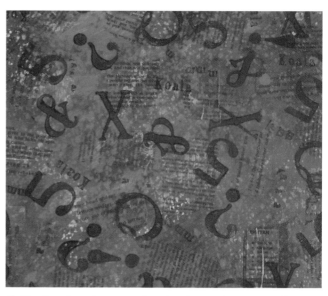

5 I could stop at this point and call it finished, or continue with an additional technique. I use the spritzing and blotting technique (see page 54) to make a water droplet pattern.

6 Finally, after the paper has dried, I apply a glaze of quinacridone burnt orange over the entire surface.

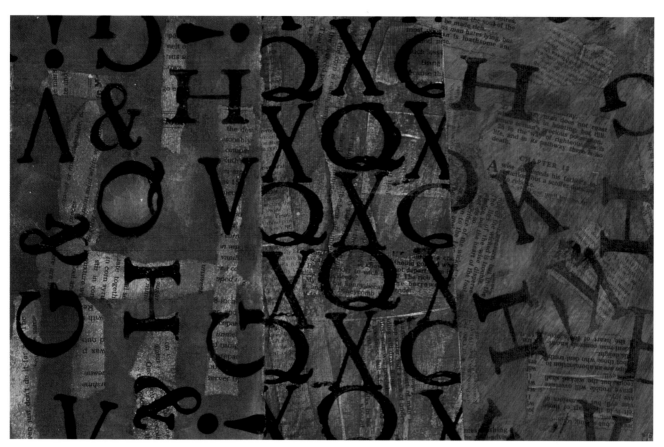

Several patterns made with book page collages and letter stamps.

combing

Combing is a technique often used in making paste papers. Basically, you apply a coat of paint, and while it is still very wet you drag a rubber comb through it.

The absorbency of your paper will partly determine how much contrast you can achieve with combing. Most water-color and printmaking papers will absorb the paint quickly, and the comb will not scrape off enough paint to produce a high-contrast pattern. For greater contrast, I recommend first applying a coat of matte medium to your paper and letting it dry before painting.

It is important that the paint be very wet when you scrape it with the comb, so if you are using this technique over a large area, work in sections.

Rubber combs are available at art and craft stores and some hardware stores. They come in several shapes and sizes, and usually have two or three sizes of teeth. Some have graduated sizes of teeth.

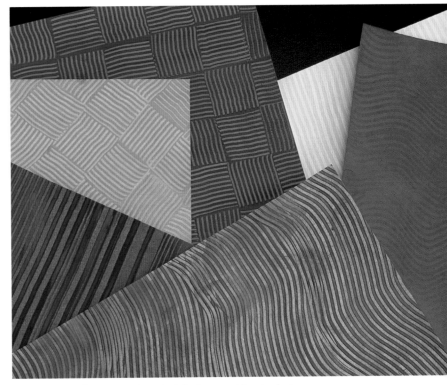

A selection of papers painted with the combing technique.

Step-by-Step Technique: COMBING

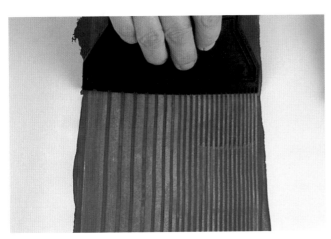

1 First I apply the paint to paper that has been coated with acrylic matte medium. In this demonstration I am using a palette knife; a brush would also work. I drag the comb through the paint. This comb has graduated teeth, so the resulting pattern is a gradation of stripes.

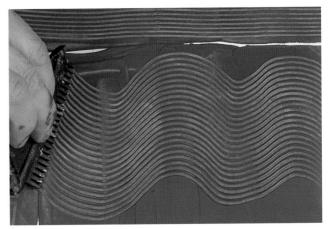

2 Different shapes and movements of the comb create a variety of different effects. Here I make a wavy line with the comb. Experiment to see how many you can make.

stamping

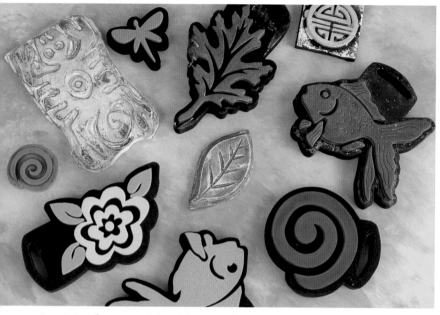

A variety of commercial and homemade stamps.

Stamping is a great way to make a pattern because it is easy and relatively quick. Stamps are widely available in a huge variety of shapes and sizes and in several different materials. Intricately carved hard rubber stamps, found in the rubber stamping department of craft supply stores, are the most expensive, but they are very durable. Stamps made of dense foam, like the one I am using in the demonstration below, are much cheaper. You can use linoleum cutting tools to carve your own stamps from soft flexible rubber that is made for this purpose. The rubber and carving tools can be found in the printmaking section of most art supply stores. You can even make your own stamp from a potato, which you may have done as a kid.

Step-by-Step Technique: STAMPING

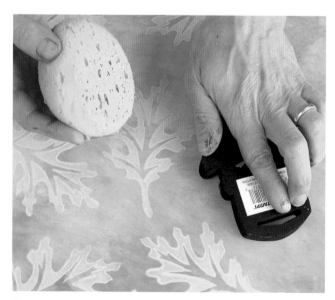

1 I apply yellow paint to an oak leaf stamp using a sponge, then stamp it on the paper, which has a yellow and green sponged background.

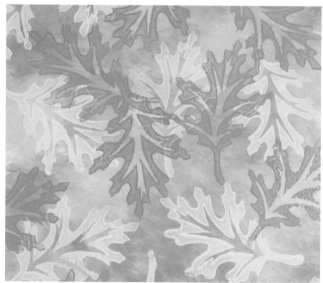

2 I add another pattern of oak leaf stamps, this time in a darker green, over the pattern of yellow oak leaves.

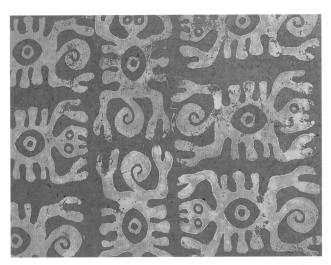

For this example I used my own handcarved stamp to make a light blue pattern on dark turquoise lokta paper.

You can stamp your pattern onto white paper and then glaze over it with a transparent color. Here I used a rubber stamp to make a grid pattern, then applied quinacridone gold with a sponge. While the paint was still somewhat wet, I sponged on black paint, working it into the gold. This technique can be used effectively for an "antiqued" look.

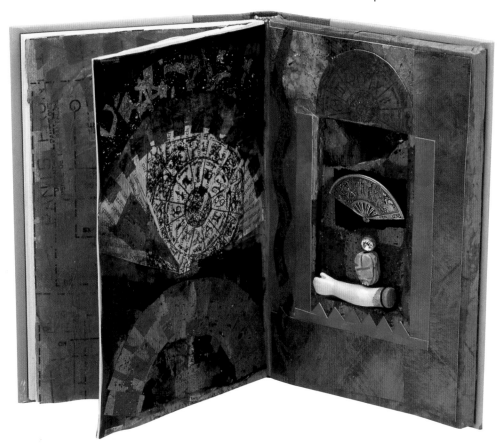

I made this altered book collage to display a few keepsakes. The fan-shaped pin inspired the repeated stamped fan shapes on the left.

masking

Masking is a technique in which you lay a perforated paper or other material over a background paper, sponge on paint, and lift the perforated paper to reveal the pattern. Lace papers—light-weight, almost transparent papers with a definite pattern in their fiber structure—are some of my favorite items to use as masks. They are available at specialty paper retailers and some art supply stores. Lace papers are relatively expensive, but they are worth trying. Inexpensive paper doilies are also fun to use as masks. With lace papers you have to work quickly so that the paint doesn't soak through the paper. With paper doilies, which are less absorbent, you have a little more working time.

A selection of lace papers, unryu (which can also be used as a mask), and a paper doily.

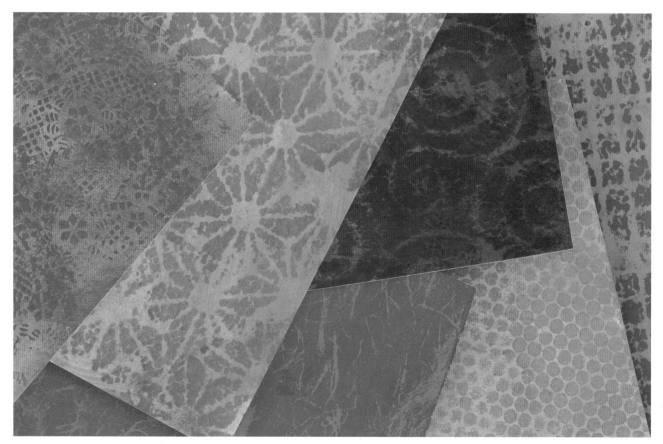

Patterns made using the masking technique.

Step-by-Step Technique: MASKING WITH LACE PAPERS

1 I lay the lace paper on my watercolor paper and sponge on magenta paint. Other tools can be used to apply the paint, but I find that a sponge allows the most control.

2 I peel up the lace paper, and its pattern is left on my watercolor paper.

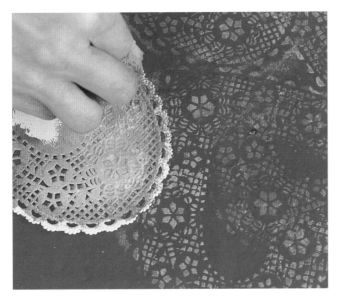

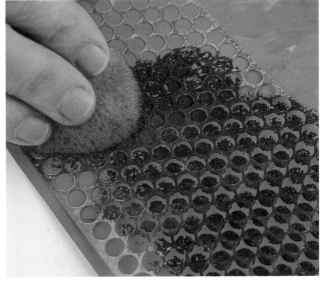

Here I am sponging pink paint through a paper doily. I repeat the process, sometimes using only part of the doily.

In this example I am using wide perforated ribbon as a mask over light purple paper. To add variation to a pattern, smudge the paint a little with a damp paper towel after removing the ribbon.

layering with gloss gel

Layering with gloss gel is similar to applying paint with a palette knife (see page 44). In this technique you mix the paint with heavy gloss gel, which is like modeling paste but transparent, and apply it in a textured manner to the paper. Once this is dry, you can repeat the process with another color, layering it over the first. Because the gel medium is transparent, the first color will show through the second in varying degrees (according to variations in thickness of application), resulting in a variegated pattern that is rich in depth and texture.

A selection of papers painted with this technique.

Step-by-Step Technique: LAYERING WITH GLOSS GEL

1 I mix some acrylic paint with the gloss gel and spread the mixture with a palette knife, deliberately creating an uneven application to make an interesting texture.

2 When this first application is dry, I repeat the process with a reddish purple paint, layering it over the magenta.

This pattern was made using the same technique, but this time I used two colors of green.

Making Textured Papers

There are many ways to create textured papers, and I demonstrate just a few here. Feel free to explore variations on these techniques and to discover your own ways of making textures. In the demonstrations that follow I create texture by adhering crumpled unryu paper or paper doilies to my watercolor paper with matte medium; by using textured mediums made for the purpose; and by applying modeling paste. Another approach is to take already textured paper—such as sandpaper, corrugated card, or any heavily textured specialty paper—and give it a coat of gesso before painting it with color.

Heavily textured papers can add depth and interest to your collages. Use textured papers sparingly to draw the eye to particular areas you want to emphasize; balance their visual weight with smooth, low-contrast papers. Or try using textured papers in abundance in your collage compositions, perhaps balancing the rich surfaces with areas of muted color.

A variety of textured papers made using the techniques in the following demonstrations, as well as some already textured papers that I have painted.

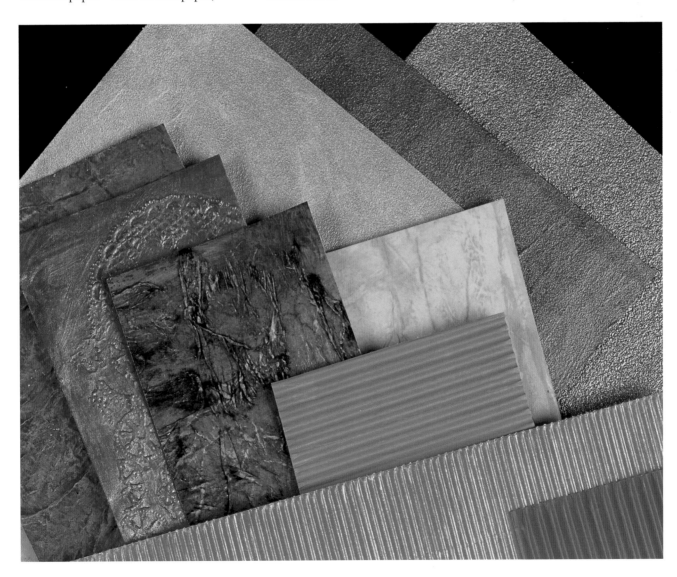

crumpled paper texture

One way to make a textured surface is to use crumpled paper. For this technique you will need a sheet of tissue-weight paper that is larger than your watercolor paper by several inches all around. Any tissue-weight or very lightweight paper will work for this technique; I like to use unryu because its long fibers add interest to the finished paper. A transparent paint will reveal the texture to a greater degree than an opaque paint will. Refer to the demonstration for using modeling paste (page 72) for an explanation of painting over texture.

Step-by-Step Technique: CRUMPLED PAPER TEXTURE

1 First I mix a little retarder or glazing medium into matte medium (or mixture of matte and gloss) to extend its drying time. I then brush a generous application of medium onto the watercolor paper.

2 I crumple the unryu slightly and place it over the wet medium so that the wrinkles are distributed more or less evenly for maximum texture.

3 The wrinkles are flattened into a texture as I brush on another coat of medium. Let this layer dry completely before painting over it. (The final painted paper is shown on page 71.)

You can use the same method for adhering paper doilies to your watercolor paper, except that you don't need to crumple the doilies because they have a rich texture of their own. I like to cut some of the doilies and use others whole for variety. (The final painted paper is shown on the next page.)

textured mediums

Just as there are matte, gloss, and glazing mediums, there are also textured mediums. These basically consist of a gloss or matte medium or gel mixed with various kinds of fibers, sand, or other coarse materials that will give a distinct texture to your painting surface. In the examples below, I applied a coarse sand medium and a glass bead medium to my paper using a palette knife.

Because these mediums are so thick with texturing material, it is much more like spreading mortar on a brick than applying paint to paper. Once the medium has dried—and this takes at least a few hours—you can apply paint to the surface. You can also mix the paint with the medium and apply color and texture in one step, but this uses a lot more paint than does the two-step method.

Watercolor paper to which a medium mixed with sand has been applied.

Glass bead medium.

A group of textured papers after they have been painted. The light green is the glass bead medium, the dark green the sand medium, the magenta the crumpled paper texture, and the blue the paper doilies (page 70).

modeling paste texture

A selection of papers to which modeling paste has been applied to give them texture.

Modeling paste is like a thick, viscous white paint, similar to gesso but heavier. It is used primarily for creating texture on your paper or canvas before applying paint. The process is much like that of preparing an intaglio or collagraph plate for printmaking; it relies on the paint getting "caught" in the textural recesses, while being wiped away from the surface. The modeling paste texture is more enhanced if you use a transparent paint, so be sure to mix in some glazing medium or other transparent medium. You can apply and then wipe off the paint in several layers using the same color, or, to add depth, in two or three related colors. You can also use gesso for this technique; because the gesso is less viscous than modeling paste, it will result in a softer texture.

Step-by-Step Technique: MODELING PASTE TEXTURE

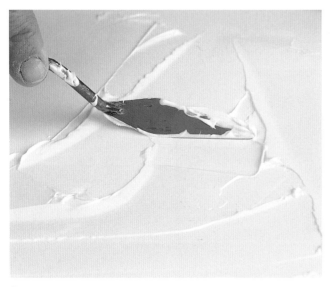

1 Using a palette knife, I spread the modeling paste over the paper as I would icing on a cake (but not as thick!). I could also use a coarse sponge, a stiff-bristled brush, my fingers, or any tool that will make a pronounced texture.

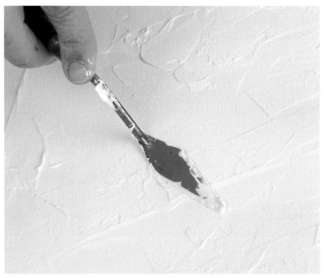

2 I play with the modeling paste and move it around until I have a pleasing texture. Here I have created a random stucco-like texture.

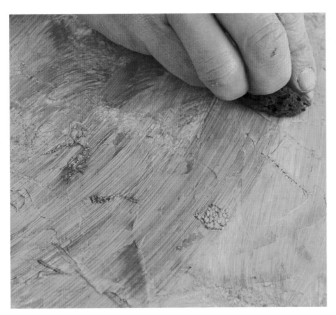

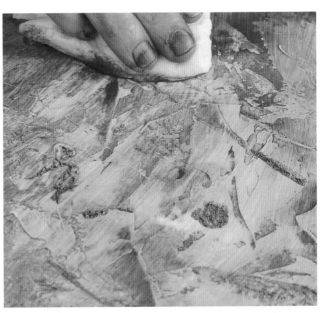

3 Once the modeling paste has dried completely, I apply the first layer of paint, quinacridone gold, with a sponge, making sure it penetrates all the crevices of the texture.

4 While the paint is still wet I wipe the surface gently with a paper towel. This removes paint from the top surfaces while leaving it in the recesses. I can control how much paint I remove by varying the pressure I apply with the paper towel.

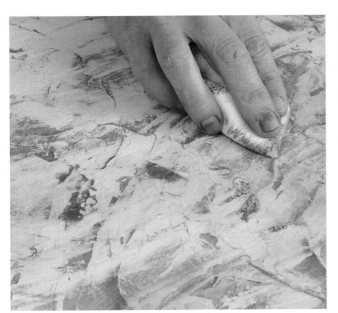

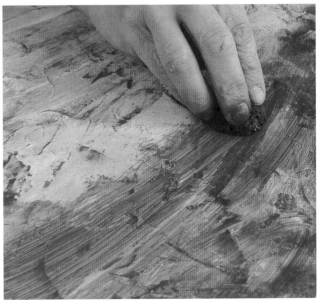

5 To further enhance the texture I wipe the surface again with a damp paper towel once the paint has dried to the tacky stage.

6 I then apply another layer of paint, this time quinacridone burnt orange, and repeat the process.

Watercolor Techniques

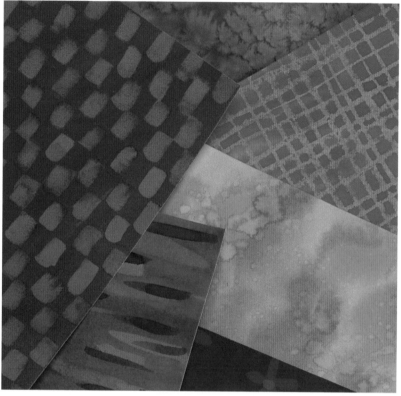

Some examples of papers painted using the watercolor techniques demonstrated in this section.

There are many technical and aesthetic possibilities in the medium of watercolor, and there are so many books on the subject I won't go into detail here. There are, however, a few watercolor techniques that are particularly well-suited to making patterns.

Watercolor artists and printmakers usually soak their paper in a tub of water before painting or printing on it to remove some of the surface sizing (see "Absorbency" on page 13) and allow more of the pigment to be absorbed. For our purposes it is not necessary to soak your paper in the bathtub. You can achieve the same result with a "quick soak" method. Simply wet the paper thoroughly using a spray bottle, let it sit for ten or fifteen minutes, then blot up the excess water with a paper towel.

Most of the watercolor techniques in this section begin with watercolor paper that has been painted with a wet-in-wet wash (see instructions below).

Step-by-Step Technique: BASIC WET-IN-WET WASH

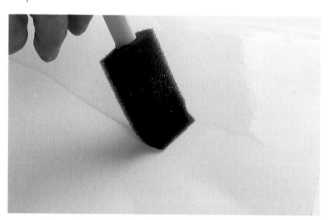

1 To create a wash, I first apply clean water to my paper with a brush or sponge brush. I wet the paper evenly so that it is barely damp. A paper that has just been "quick-soaked" is probably damp enough.

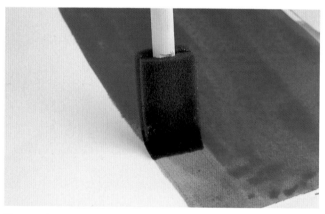

2 I apply paint or dye in broad, even strokes with a brush or sponge brush.

subtractive painting

I call this technique subtractive painting because the pattern is created by lifting, or subtracting, paint. After your wash is dry, apply your pattern with water. In the following demonstration I use a brush to make a flower pattern with brushstrokes. You could also use a sponge brush or a sponge stamp to create a pattern in water. Let the water sit for a minute or so, then blot it gently with a paper towel. The longer you let the water sit, the more paint will be removed by blotting, to a certain extent. Work on small sections, applying water and blotting before moving onto the next section.

Step-by-Step Technique: SUBTRACTIVE PAINTING

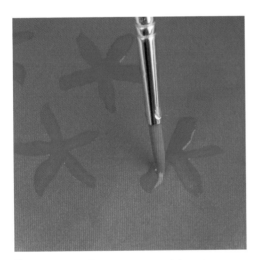

1 I apply my flower pattern with water using a brush.

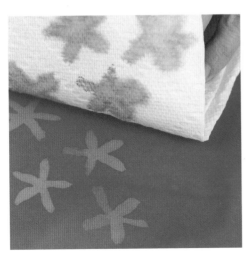

2 After letting the water sit for a minute, I blot it with a paper towel.

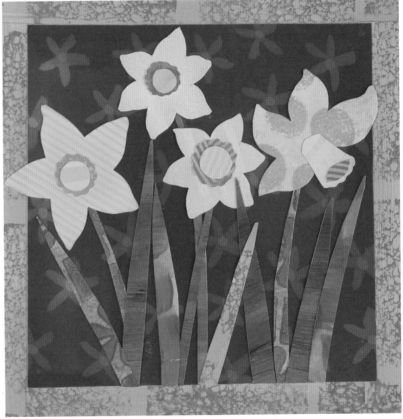

Here I used the same paper painted with the subtractive technique as a background for the daffodils.

crayon resist

You may have done some version of the crayon resist technique as a child, perhaps to create patterns on Easter eggs. It has a kind of "invisible ink" aspect to it, since the crayon pattern (if drawn in white or clear crayon) is revealed only when the paint is applied. For this technique I recommend that you draw your pattern first, before quick-soaking your paper. After blotting up the excess water from the quick soak, apply your watercolor wash. White crayon and dark paint will yield the most dramatic results, but you can also create a tone-on-tone effect by using two closely related colors.

Step-by-Step Technique: CRAYON RESIST

1 I create a plaid pattern using a white crayon.

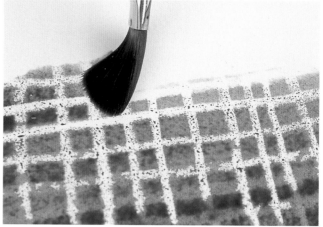

2 I then apply a wash of deep blue.

The finished result has a very distinctive look.

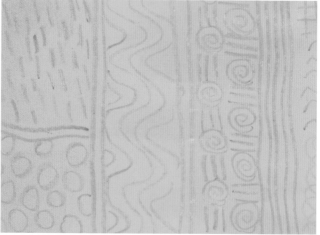

For this pattern I began with a yellow crayon design, then applied a deep yellow watercolor wash. This process creates a more subtle tone-on-tone pattern.

spritzing

Spritzing water onto a damp watercolor wash produces an instant pattern. The patterns produced can vary from distinct water droplets to elaborate crystalline effects, depending on the particular paint or dye. After applying a wash in watercolor paint or dye as described above, let the paint dry until it is just damp. Spritz water onto it with a spray bottle and let the water droplets create a pattern. This technique will work with both paint and dye, but the results are more dramatic with dye. Even after the paint or dye has dried completely, you can spritz it again for an additional, more subtle effect.

Step-by-Step Technique: SPRITZING

1 First I apply an even wash of green watercolor dye.

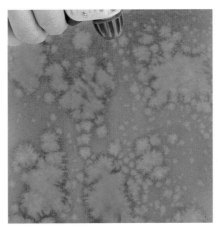

2 I use a spray bottle to spritz water onto the damp wash.

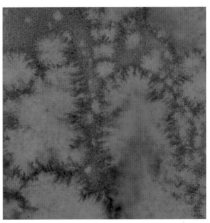

The result is a pattern of water droplets that bloom and spread into each other.

Here I created a "variegated" pattern by wetting the paper and dripping two colors of dye (purple and magenta) onto it. Once the paper was dry I spritzed it heavily with water and let that dry. I then spritzed a lighter application of water droplets onto it.

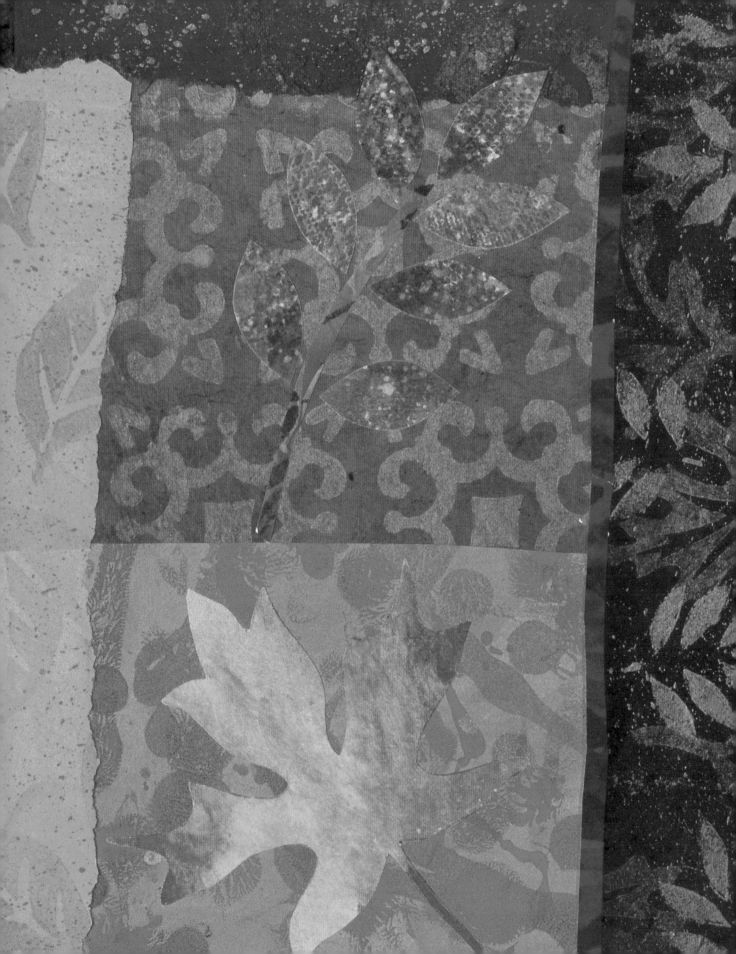

Collage & Composition

Composition, in the context of this book, means the arrangements of elements and their relationships to one another within the frame of your collage. There are no hard-and-fast rules for composing collages; your artistic vision will guide your design. However, if you're intimidated by the overwhelming range of possibilities or need a starting point, this chapter may be a useful place to begin. In the following pages, I will discuss a number of factors that will affect your composition. We will also explore various approaches to composition and try out some fun "warm-up" exercises to get the creative juices flowing.

Creating Unity

This abstract composition is symmetrical with respect to shape—the shapes on either side of the central axis are roughly mirror images—but asymmetrical with respect to color.

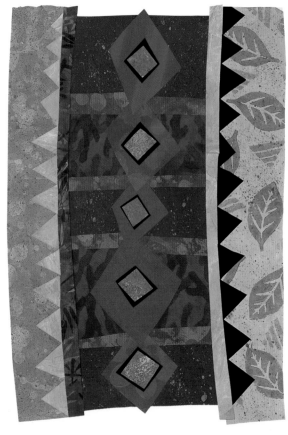

BELOW: In this design there is a purple vertical line on either side of the central axis, creating a sense of balance; the other elements are asymmetrical.

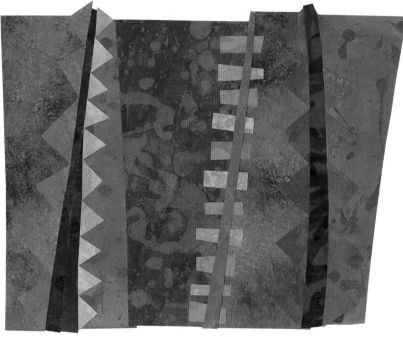

A number of factors will affect your composition. For example, do you have one central image in the middle of the page? Do you have several elements spread out evenly or bunched together? Are your elements arranged symmetrically or asymmetrically? Do you have one element that catches the eye, or are there several elements that demand equal attention? Does your image appear to be part of a larger composition, or is it self-contained?

Unity is a word often used to describe the characteristic of a composition that "hangs together" or looks right. A composition is unified when it looks as though the elements relate to one another in a way that makes the composition a whole, not merely the sum of its parts. A composition is not unified if it looks like a random jumble of miscellaneous elements. This sense of what looks right is largely subjective, but there are some basic principles of composition that can help you articulate your own sense of unity.

Symmetry & Asymmetry

A composition is symmetrical when its elements are placed in corresponding positions on either side of a central axis. Think mirror image. In practice, however, the two sides of an asymmetrical composition need not mirror each other; rather the elements must be organized and balanced with respect to a center line or point. Symmetry creates balance and stability in a composition, but too much symmetry can make your composition look static or unexciting. Asymmetry is the principle of organization that does not refer to a central axis. Asymmetry can create a dynamic composition, but it can also make a collage

look lopsided or unbalanced. Your collages may have some aspects of symmetry and some of asymmetry.

In general, symmetry and asymmetry should be used as principles of analysis after the fact, and not as guides to direct the development of your composition. While you are in the midst of composing a collage, it is best to go with your gut feelings as to what looks right. If your collage looks static, unbalanced, or lacks a sense of unity, then look at it in terms of symmetry and asymmetry and try applying the principles described above. In your warm-up exercises (see page 91) you may want to apply the principles of symmetry and asymmetry deliberately in order to become more familiar with them.

Repeated Elements

One way to create unity in a composition is by repeating an element. The repeated element can be a color, a shape, an edge, or a line. Within this repetition, you can create variety. For example, if you are repeating the shape of a rectangle, you could vary the sizes and proportions of the rectangles. If you are repeating a color, you could cut different shapes from that color, or use several different patterned papers that are predominantly of that color. In the composition at the beginning of this chapter (page 78), we see the color green repeated in several different patterns, as well as a repetition of rectangular shapes.

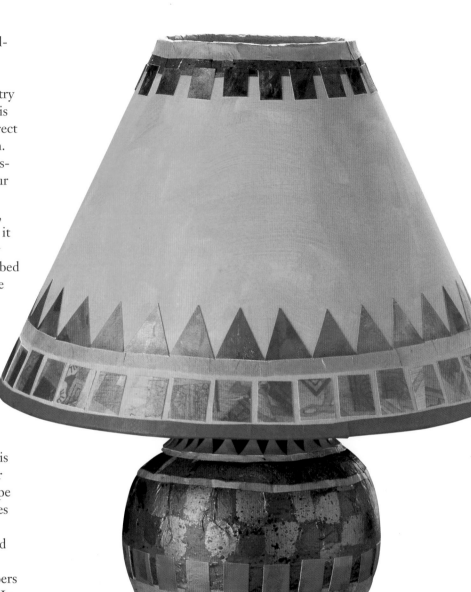

RIGHT: In this lamp made out of a bisque vase I painted and collaged (see instructions on page 122), the rectangles in the base echo the rectangles in the shade.

Figure/Ground Relationship

The figure/ground relationship refers to the relationship between the image (figure) and the background (ground). In chapter 3 we discussed motif and background in the context of patterns, which is the same thing, only in a composition you may have a central image rather than a repeated motif. The figure is sometimes referred to as "positive space" and the ground as "negative space." This relationship between figure and ground can be very distinct, with emphasis on either the image or the background. The figure and ground can also be given equal "visual density" (see below) so that they seem to compete with each other. In many compositions the relationship between figure and ground is so ambiguous that the negative space may look like an image rather than the background.

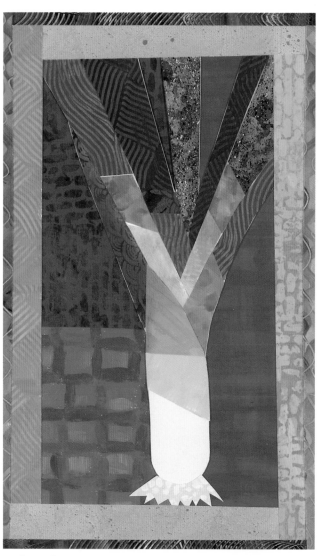

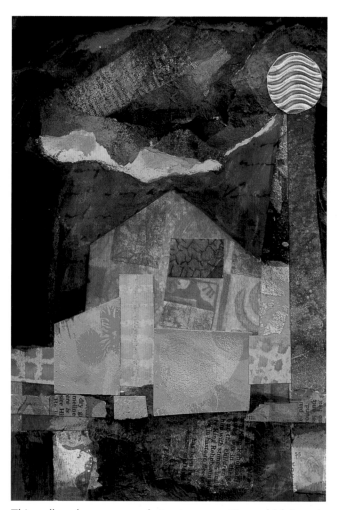

This collage began as an abstract composition, which I gradually worked into a house in the moonlight. Partly because I did not set out to depict a figure, the house (the figure) and the ground seem to merge into one another, with some areas of ambiguity between the figure and ground.

In this collage it's easy to distinguish the figure from the ground. The leek (the figure) is separated from the background through the use of complementary green and red, although the figure and ground have equal weight.

Visual Density & Focal Point

By visual density I mean the degree to which an element of a composition commands your attention. Visual density is also sometimes called visual weight. The part or parts of a composition that draw your eye are more visually dense, or have more visual weight, than other areas of the composition. Visual density is a relative term. An element that appears visually dense in one context may appear rather spare in another, depending on the elements surrounding it.

Several characteristics make an image or element of composition visually dense: intense color, lots of texture, a sparkly or metallic finish, high contrast, and a busy pattern. On the other hand, muted colors, flat texture, or a sparse, open pattern carry less visual weight and allow resting space for the eye. Generally, in composing an image, you want to balance visual density. If you have a very dense element, give it some breathing room with areas of spare, open space; otherwise it will get lost.

The concept of visual density can be used to establish a "focal point"—a primary area of interest—in a composition. For example, on a scrapbook page in which the central image is a photograph, you can draw the eye to that photograph by giving it a border that is visually dense—thus eye-catching—and then surround it with more visually sparse elements to give it some breathing space.

Balancing visual density is by no means a requirement. You may want to create a collage that has equal visual weight throughout. In such a case you may not have a focal point, but rather an "allover" pattern. The collage *Beach Houses* on the title page doesn't have one main focal point, but looks rather busy all over like a repeating pattern.

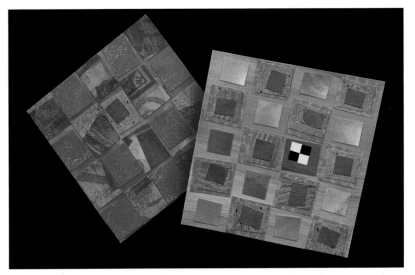

In the composition on the left, the green square with the red square in the middle is the focal point. Because there are many similar elements in the example on the right, the red and green squares fade into the background while the black-and-white square takes center stage.

Block Party is an example of a composition that leaves space around a dense image. Each quilt block character is composed of many small pieces of paper, incorporating lots of texture, contrast, and bright color. To balance these four dense images, I've surrounded them with plain, deep red areas and a simple border.

A composition like *Sushi* is clearly intended to be viewed in one orientation only.

Orientation

Orientation is simply the direction in which the collage lies in relation to the viewer. If your collage is a rectangle, for example, you may intend it to be viewed horizontally or vertically. If your composition is symmetrical from various orientations, such as in the case of a mandala or a quilt block design, it may be viewed from several orientations. You can exaggerate a vertical or horizontal direction. Also pay attention to the orientation of the elements within the collage. If you have, for example, a strong vertical composition, play with elements that either reinforce the vertical thrust or counterbalance it.

I call this collage and the ones on pages 78 and 80 "rug" designs, because they are intended to be viewed from any direction. In this design we see repeated rectangles and triangles as well as repeated colors.

Approaches to Composition

As you gain experience in collage you will find your own approach to composition, but I want to suggest some basic methods that you might find helpful as starting points. I think of these approaches as a continuum from the completely predetermined to the completely spontaneous, rather than as distinct methods. I find it best to use some combination of methods, predetermining some aspects of a collage but always leaving the door open for spontaneous additions and revisions.

Planning Ahead

The first approach to composition is to work out your entire design before cutting and pasting your papers. This method requires the most forethought and planning; it is very much like making a pieced quilt block or a stained glass pattern, in that all the pieces must fit together like a puzzle.

Make an outline drawing of your composition to use as a template and cut each of the pieces from the template. Be sure to mark the "right" side of each piece (as opposed to the side that will be glued to the background paper) and to indicate where the piece fits into the composition. For a complex design I make a tracing of the outline drawing, label each part with a letter or number, and then correspondingly label the original outline drawing before cutting out the shapes. Choose your papers for each of the parts, and use the cut-out shapes as templates to cut your collage elements. Since your shapes are all supposed to fit together like a puzzle, accurate cutting is important. Make sure to observe your markings indicating which side is facing out. Position all of the elements to see that they fit together before gluing them down.

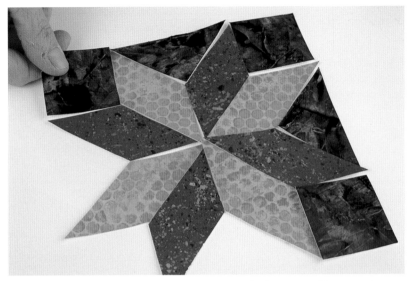

For this traditional quilt block design, I assemble the pieces like a puzzle to make sure they fit before gluing them down. (See page 126 for a template.)

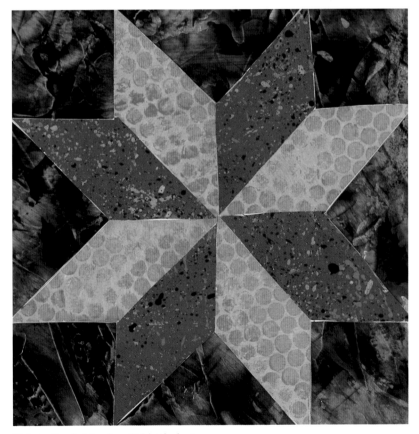

This is the finished quilt block design.

This method of predetermining your design completely before cutting and gluing your collage parts works well for simple images like the quilt block gift cards shown here. However, it can be frustrating if your pieces don't quite fit together and you have some white paper showing through the cracks. You can cut yourself some slack by gluing your cut paper image over a colored background.

These are some gift cards I made with simple quilt block collages.

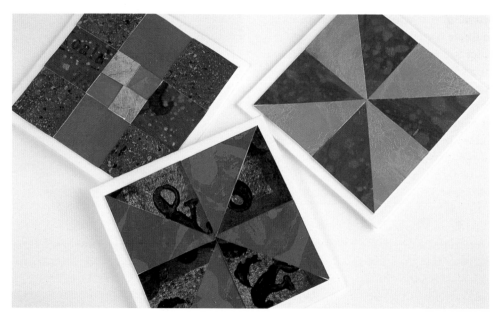

BELOW: For these fan cards, I glued the pieces over a colored background so that the white paper wouldn't show through if the pieces didn't match up exactly.

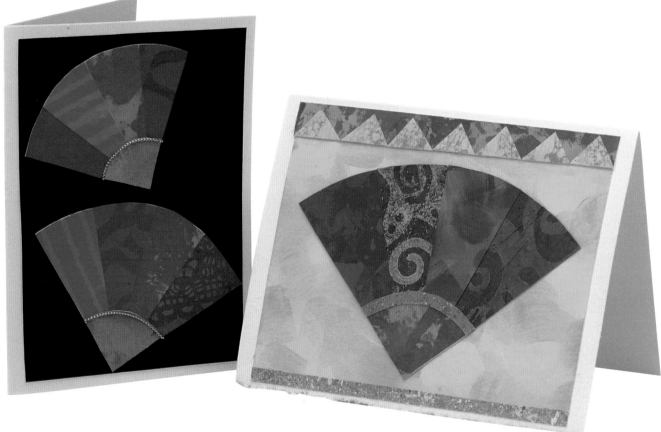

Playing with Collage Elements

A second approach to composition is to make individual collage elements and then play with their arrangement on a background before gluing them down. You can try different backgrounds and combinations of elements and consider a range of possibilities before committing to a final composition. It is fun to work on several different collages at once in this way, switching components from one to another to experiment with various possibilities. You could create a series of related images this way, or simply give yourself several options in creating a single composition.

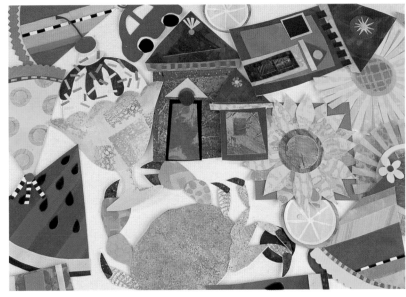

An assemblage of collage "spare parts" in search of compositional contexts.

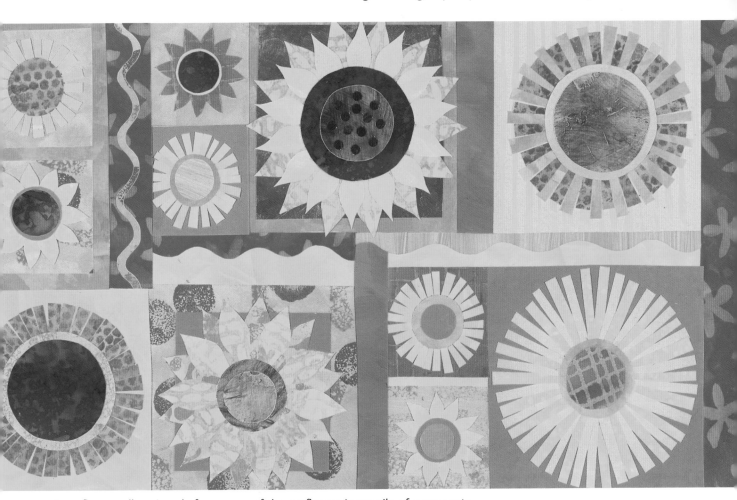

A sunflower collage I made from some of the sunflowers in my pile of spare parts.

Intuitive Composition

The third and most intuitive way of working is to cut out shapes and glue them down as you go. You might start out with a general idea of how your collage will look or what you want it to represent, or you could just begin with an abstract shape that pleases you. In either case, you can let what you have already done guide you in your decision of what to do next. This is how I approached the series of "rug" designs on pages 78, 80, and 84. I started with the idea of the basic format and some of the geometrical elements, and then proceeded to glue down the elements as I felt they looked "right."

Alternatively, you could arrange the elements first and then glue them down. Once a piece is glued down, it is difficult to remove it and start over. Collages composed in this manner will often have a fresh and unexpected look, whereas if you arrange and rearrange the elements repeatedly before making compositional decisions, you can lose the benefit of your intuitive visual sense. The challenge in this approach to composition is to be decisive and direct, going with your gut reactions.

In the following example I am making a collage on the lid of a box (see page 107 for instructions on making the hardcover box and lid).

My selection of papers for the box lid collage. I begin with the lid as a format and choose a collection of papers from scraps and loose ends, assembling a group of colors that works for me.

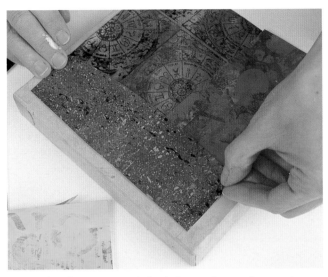

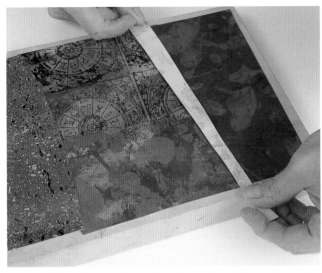

First I glue down some relatively large pieces of paper to establish the main areas of composition.

When the background is in place, I continue by cutting and pasting smaller elements.

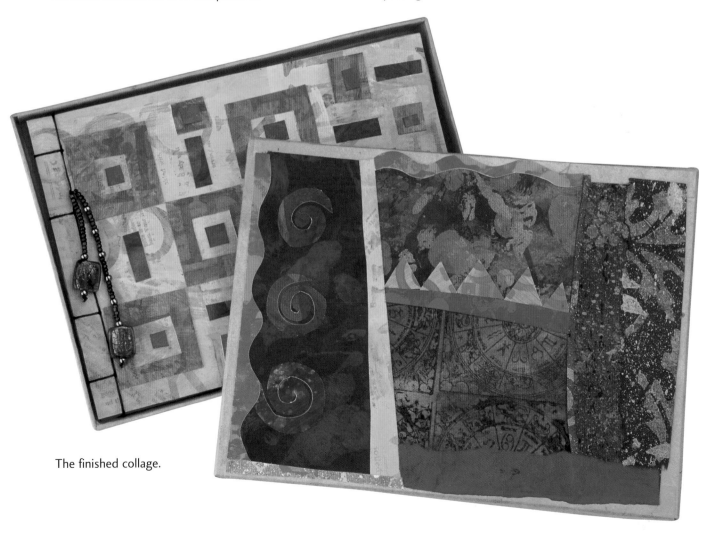

The finished collage.

Collage & Paint As You Go

So far I've described the process of first painting papers, and then making collages that you can display as artwork or use to make paper crafts. Another approach is to collage and paint as you go, using your decorated papers but also adding layers of pattern and color as your composition develops. This is a fun way to make scrapbook pages or to integrate found papers and ephemera into your collages. This process can be very spontaneous and intuitive and can result in rich imagery and surface texture.

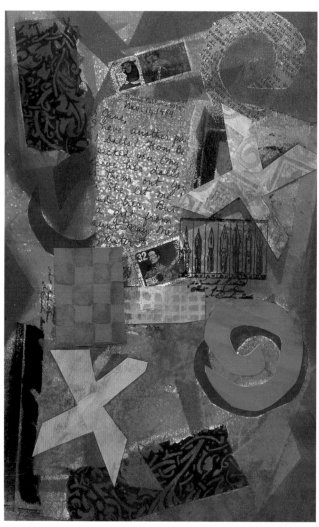

XO was inspired by the handwriting of a friend who always puts Xs and Os at the bottom of her letters. I first photocopied some of her letters and collaged them onto the background, then proceeded to paint, print, and collage until I was satisfied with the composition.

For this very small collage called *Letter from LaHave,* I took as a central image the figure of a polar bear from a Canadian postage stamp, then proceeded to build up the rest of the collage from there.

Warm-up Exercises

You now have a whole collection of handpainted patterned papers, some compositional principles, scissors, and glue at the ready. The unlimited possibilities can seem overwhelming, and you may have a hard time choosing where to start. In the following paragraphs I suggest a few exercises to help you focus and find your own starting point. These are not intended to be instructions for making finished compositions, though they may well lead to that. Rather, they are just some ways to explore your materials and warm up to the process.

You can invent your own warm-up exercises, too. I think of them as points of entry into my own creative groove. From a creative standpoint, it is a good idea to have several different points of entry. Sometimes the time you set aside for creative activities does not coincide with your inspiration. Warm-up activities can help generate inspiration when you need it.

Stripes, Plaids, Checks & Dots

When in doubt, stripes, plaids, checkerboards, and polka dots are easy and versatile motifs to explore. Stripes can be wide, narrow, straight, wavy, crooked, or uneven. Plaids are just two sets of perpendicular stripes, so the same versatility applies. Checkerboards need not be limited to squares. You can use any motif to begin a checkerboard, and then fill in the alternate spaces with another motif, or add another element over the first one, or both. Dots can be laid out in a measured grid, a half-drop pattern (which is like a checkerboard), or a random, allover design. You can vary the scale and use different sizes of dots to make a more complex design. Use a combination of patterned and solid

papers to work with these classic motifs. Once finished, you can use your warm-up exercises to decorate any of the paper craft pieces demonstrated in chapter 5, or just keep them for reference or as inspiration.

Stripes can be straight or crooked, wide or narrow. You can vary the edges of your stripes by cutting or tearing the paper.

You can make plaids by layering perpendicular sets of stripes, or by actually weaving strips of paper.

An assortment of checkerboards. By varying the scale of squares and incorporating other elements simple checkerboards become complex designs.

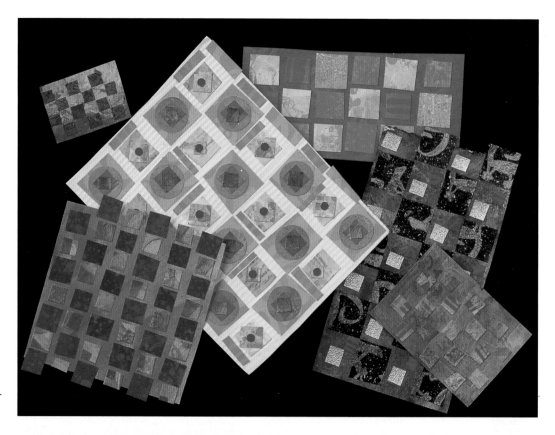

BELOW: I used a dot design for this paper billfold.

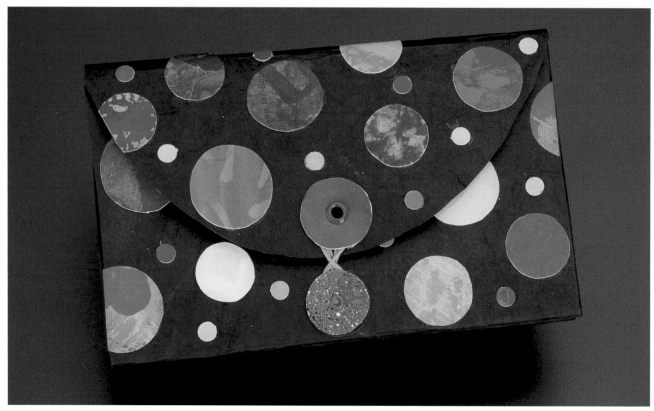

Abstract Shapes

This exercise allows you to consider a number of compositional options from a single arrangement of shapes. Start by cutting out shapes from your decorated papers or from plain colored paper, such as construction paper or colored card stock. In addition to simple geometric shapes, such as circles and rectangles, try getting adventurous with variations on spirals, squiggles, or multilobed amoebic shapes. Vary the edges of your shapes, making some curved and graceful, others jagged or torn. Also vary the sizes of your shapes for more dynamic compositions.

Once you have your shapes, you can create as many compositions as you like using the procedure shown below. Remember that this exercise is designed to generate ideas and inspiration, not necessarily to produce a finished collage.

FAR LEFT: Cut random abstract shapes from a group of papers, as many as you like. Using some or all of the shapes, arrange them randomly on a background. You can use either a patterned paper or a solid color for the background.

LEFT: Cut a square or a rectangle from a blank piece of paper to create a window mat or frame. Place this "window" over your abstract shapes, moving it around to explore the different compositional possibilities.

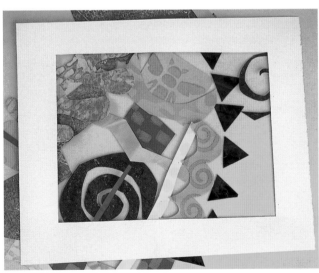

Try turning the mat the other way for a different orientation.

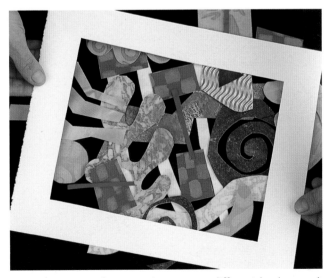

Or try arranging the same shapes on a different background.

One Subject, Ten Collages

For this exercise, pick an object or symbol that has a very simple but recognizable shape. Hearts, stars, spirals, fish, Christmas trees, footprints, and leaves are all good options. Working in a relatively small format, make ten collages depicting your chosen object. Vary the size, shape, color, background, and embellishments. Make some collages that are very simple and some that are more complex. You may find a particular format that works for you, or you can vary the format. Or, you may want to make each one very different from all the others.

This exercise is not necessarily meant to result in exactly ten collages. I suggest ten because when you are working in multiples you are less likely to get too picky over each collage. Exploring variations on a theme allows you to work freely and intuitively within a set framework. You many find that after only two or three collages you are inspired to move on to something else. On the other hand, you may want to continue your series beyond ten.

For these heart collages I found a single format and made variations in color and proportion.

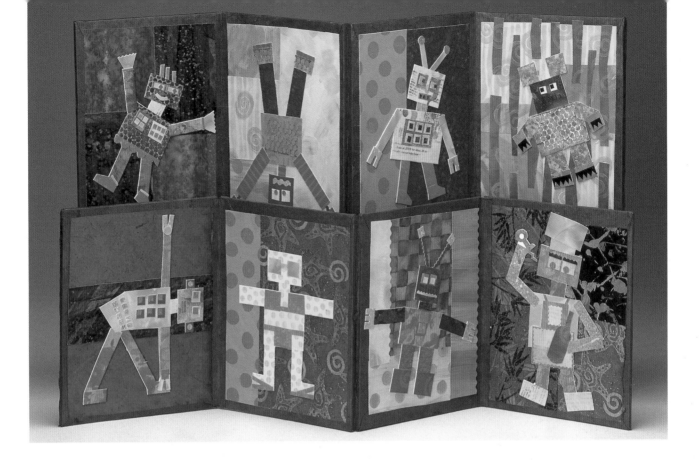

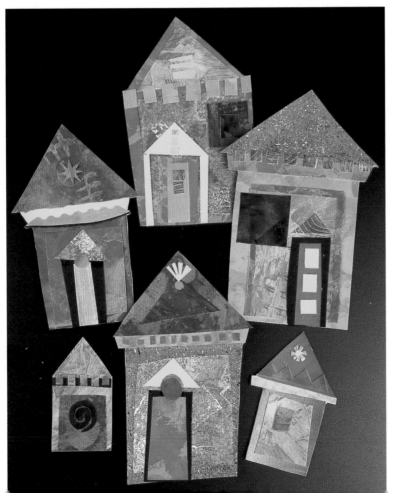

I made this series of robots when I was feeling particularly uninspired and needed a starting point. After only the first robot I was totally absorbed in my collages and having way too much fun!

These beach houses were inspired by a quilt appliqué design. As with the robots, once I finished the first one, I couldn't wait to try a whole series of variations.

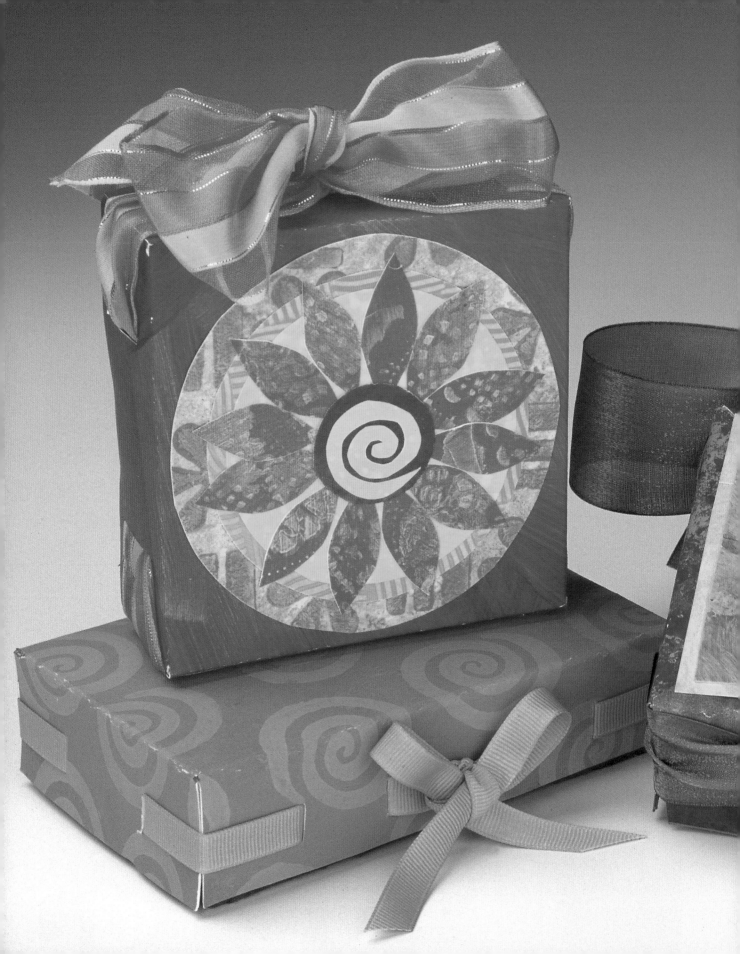

CHAPTER 5

Crafting with Collage

Collage can be an exciting and expressive art form in itself. However, it is also fun to incorporate collage techniques into craft projects. In this chapter we explore some paper craft projects that integrate the decorative paper and collage techniques demonstrated in the previous chapters. We will start with gift tags, cards, boxes, and books and journals, and then explore some ways of using collage on other decorative, whimsical pieces, such as jewelry and vases. Ultimately I hope these projects will inspire you to come up with your own ways of crafting with collage.

Gift Tags & Greeting Cards

Greeting cards and gift tags can be made for particular occasions, or they may serve as formats for exploring collage. The warm-up exercises described in chapter 4 can also be used to adorn cards and gift tags. Any gift is enhanced and personalized by the inclusion of a handmade card. A set of collaged note cards can make a unique gift, especially when it is presented in a handmade box.

To make a simple greeting card, fold a piece of heavy paper, cut it to the size you want, and decorate it with collage. A gift tag can be made in the same manner or can be cut to the desired size and left unfolded. To make more complex cards, you can laminate the paper to give your card a lining (see "Laminating" on page 101), as I have done in the birthday card on page 42; or you can sew in a few pages using the pamphlet stitch demonstrated on page 102.

Once you've folded your paper in half you can turn it either vertically or horizontally to make your card.

BELOW: A selection of gift tags.

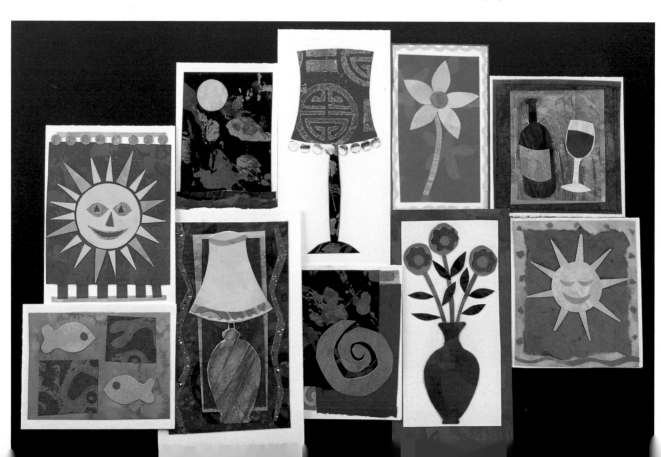

pop-up cards

An easy pop-up mechanism can add dimension to a card. Pop-up cards can look very complicated and impressive, but most pop-ups are based on a few simple mechanisms. This is one of the simplest mechanisms, and it is well suited to greeting cards. See page 126 for a diagram of the pop-up mechanism.

Step-by-Step Project: **POP-UP CARD**

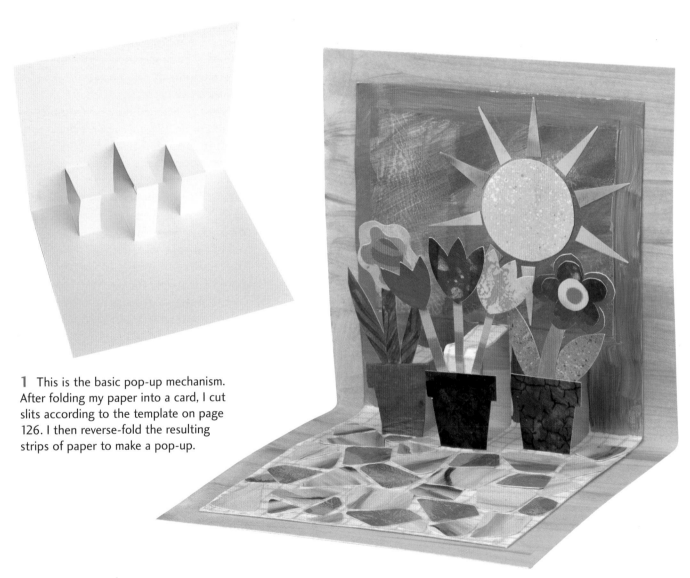

1 This is the basic pop-up mechanism. After folding my paper into a card, I cut slits according to the template on page 126. I then reverse-fold the resulting strips of paper to make a pop-up.

2 For my *Pop-up Patio* card I used scraps of patterned papers to make flower shapes and then glued them onto the vertical portions of the reverse-folded strips of paper.

Books & Journals

The possibilities for personalized albums, scrapbooks, or journals are endless. You can use them for sketches, recipes, photographs, addresses, or for writing down your own reflections. A handmade book makes a very special and personal gift. Your collage can reflect special things about the person for whom the book is intended, or simply add decorative elements to an otherwise plain book.

Making books can be a very time-consuming and exacting craft. Many methods of constructing books involve intricate stitching and other skills that are mastered only with a lot of practice. However, there are other methods of book construction you can use to produce satisfying results on your first try. Here I will focus on a simple bookbinding technique called pamphlet-stitched binding. With this technique, you can create a book, start to finish, in under half an hour; the stitching itself takes only a few minutes.

In the following demonstrations I am making blank books that I'll later fill with notes, sketches, recipes, or some other content. Another approach is to create your finished pages first, and then bind them together.

Paper

I refer to the paper used for the pages of a book as text weight paper. "Text weight" is not a specific type of paper. The term refers to any paper that is an appropriate weight for the text block (the stack of papers that make up the pages of a book). Ordinarily, paper used for the text block is of lighter weight than that used for the cover, but this is not a hard-and-fast rule. For your text block you can use ordinary typing paper, colored or white card stock, 90-pound watercolor paper, embellishment papers (sold for use in scrapbooks and other paper crafts), or even delicate parchment or onion skin paper. Be sure to check the grain (see "Grain" at right) of the paper, and fold the signatures accordingly. For the covers, use your decorated watercolor or printmaking papers, or a blank paper of approximately the same weight.

Bookbinding Tools

There are a few tools for bookbinding that will make the job easier, though they are not absolutely essential. The

I made this pamphlet-stitched book to use as a journal.

first is a bone folder. It is made of plastic and looks like a broad letter opener. Available at bookbinding suppliers, art supply stores, and some craft supply stores, bone folders are used for scoring and folding paper. Use a letter opener or a dull butter knife as a substitute. The second tool I recommend is an awl, which is used for punching holes. Awls are usually available at hardware stores and art and craft supply stores. A heavy-duty pushpin is an adequate substitute for an awl in pamphlet-stitched binding. Binder clips are handy for holding book pages and covers together while you punch the holes. The other tools you will need—a sewing needle, a hammer, and a scrap block of wood—should not be hard to find around the house.

Making the Signatures & Cover

A signature is a group of folded sheets of paper nested into one another for the purpose of creating the pages of a book. A book can contain one or more signatures. To make the signature, cut and fold your paper, along the grain, into individual folded sheets that are the size you want your pages to be, then nest them together. I suggest that you not use more than eight sheets nested together, depending on the thickness of the paper.

Cut the cover $^1/_4$ to $^1/_2$ inch taller than the text paper, and $^1/_4$ to $^1/_2$ inch wider than the unfolded text paper. Fold the cover, and nest the signature into it. There should be a $^1/_8$- or $^1/_4$-inch overhang on the top, bottom, and fore edge.

Laminating

Laminating the cover makes it thicker and stronger; it also adds a decorative element, because the cover will be colored on both sides. You can also laminate paper to use for cards, boxes, and other projects. To laminate the book cover paper, cut it to the appropriate size and glue it down to a piece of coordinating paper that is slightly bigger than the cover paper. Weight this between sheets of wax paper under heavy books until the glue dries. Then, cut the coordinating paper along the edge of the cover paper. You can fold the cover paper before laminating it, then re-establish the folds before proceeding.

A few bookbinding tools.

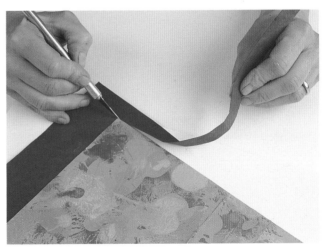

After laminating the cover, I carefully cut away the excess with a sharp craft knife to ensure even edges.

pamphlet-stitched binding

Pamphlet-stitched binding is one of the simplest types of bookbinding. It is quick to accomplish and very versatile. The basic pamphlet stitch uses three holes to sew a single signature (which can be a single folded sheet of paper for a greeting card, or several sheets nested together for a book) to a soft cover. You can also use this stitch to bind two signatures to a cover, as I will demonstrate.

The only materials needed to make pamphlet-stitched books are paper, thread, and, if you are laminating the cover paper, glue. For the cover, you can use your decorated watercolor paper or any paper of similar weight.

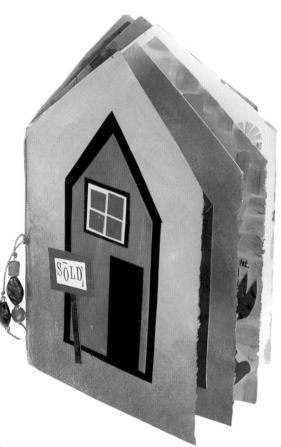

The House That Uncle Dean Bought. I created this pamphlet-stitched book by first making my finished pages and then binding them together.

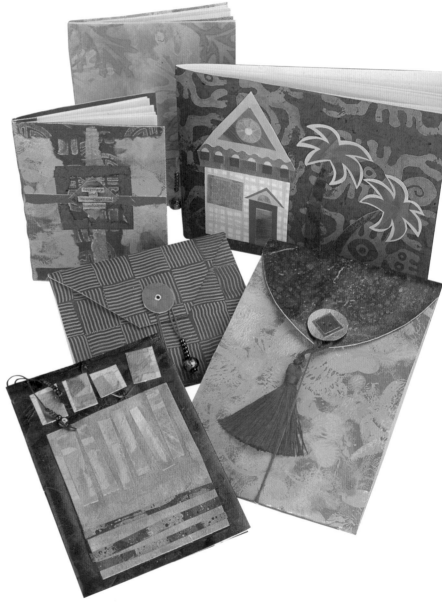

A selection of pamphlet-stitched books.

1 I open the book and mark three holes along the center fold: one in the center, and two a short distance from the edges of the top and the bottom. Using the awl, I punch holes through all layers of paper at each of the three markings. I then mark the holes on the outside and punch through the spine.

2 I am ready to sew. Using a piece of ribbon 3 1/2 times the length of the spine, I sew through the center hole from the outside to the inside, leaving a tail long enough to tie a bow. I could also use embroidery thread, waxed linen thread (a classic bookbinding material), yarn, wire, or any thin cord.

3 Next I sew through the top hole from the inside back to the outside and pull my ribbon tight.

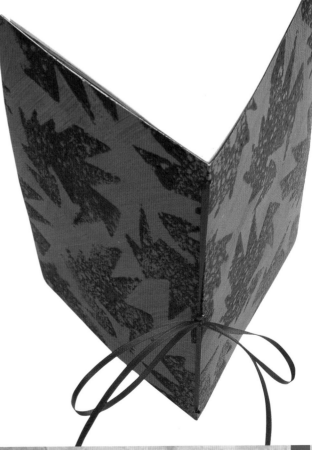

4 From here, I sew through the bottom hole from outside to inside. Finally, I sew back through the center hole to the outside, making sure the thread I am sewing with and the tail I've left are on opposite sides of the cord running down the outside of the spine.

RIGHT: **5** I gently tug the cord to make it snug, and then tie a knot. I can either cut the cord close to the knot, or use the excess to tie a bow or add some beads. I could also do this same stitch starting from the inside. In that case the decorative treatment would show inside the book.

A variation on this type of book construction is to bind two signatures together. The sewing is exactly the same, but the preparation of the cover is different. The width of the cover needs to be twice the width of the signatures plus enough for overhang, plus extra length for the inside fold through which the signatures will be sewn. 1½ inches of extra length will give you a ¾-inch inside fold.

1 I fold the cover paper inside out along the spine first and smooth down the fold using a bone folder.

2 I then fold the front and back in opposite directions, one at a time, so the insides are together and the fore edges meet. If your paper cracks along the spine, touch it up with matching paint.

3 I fit the signatures into the cover along the creases of the inside fold.

4 I lay the book flat and punch holes through the spines of both signatures and the creases of the inside fold. Starting from the inside of either one of the signatures, I then sew through the spines of the signatures and the inside fold as described in the first demonstration.

Boxes

Handmade boxes are easy to make, and they enhance any gift, turning an ordinary object into something special. I learned to make boxes one year when I was short of funds for holiday gifts. I chose very inexpensive gifts for everyone on my list—candles, chocolates, soap, and the like—and made a special box for each. The object itself was the excuse for the box. Needless to say, everyone was thrilled with the gifts! I've continued my practice of choosing the object to be contained first, then constructing the box accordingly. You can follow this example or construct the box first and then find or make something to put in it. The collage imagery on the box can relate directly to the object inside. For example, you could use a gardening theme for a box containing seeds or gardening tools, a candle collage for a box containing candles, a sewing theme for a sewing box, and so forth. On the other hand, you may choose to plunge into making boxes as decorative containers, and then find or make objects to put in them.

These boxes were made using the simple folded gift box technique shown on the next page. This technique works well for short or tall boxes.

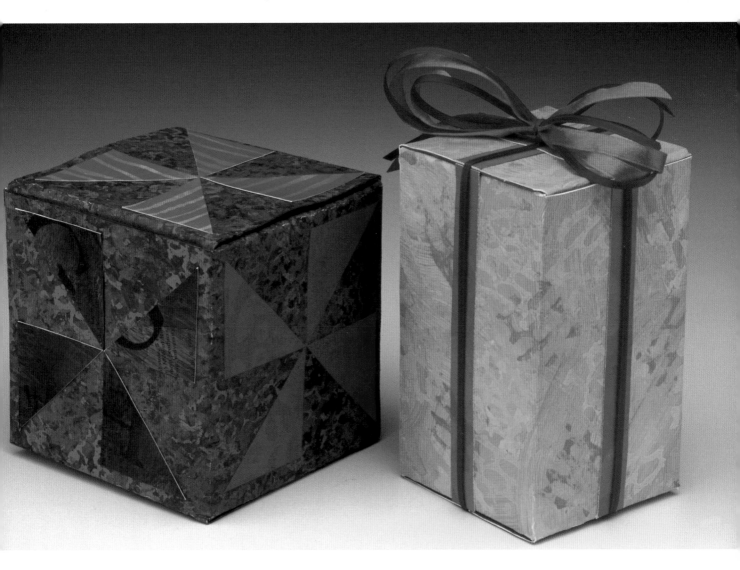

BOXES **105**

simple folded gift box

For this type of box I like to use my decorated watercolor paper and laminate it (see page 101) with a lightweight lokta or patterned paper. If you want to laminate your paper, do so in step 2, after scoring and folding it. This box is very simple and quick to make, but accurate measuring and cutting are important.

Step-by-Step Project: **SIMPLE FOLDED GIFT BOX**

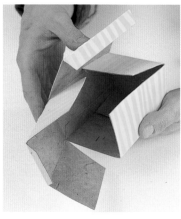

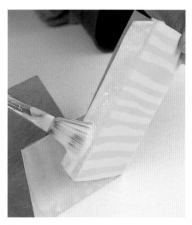

1 I first determine the dimensions I want my box to be and make a template accordingly, using the template on page 127. I trace the template onto my paper and cut it out. I then mark the fold lines lightly in pencil.

2 I score the folds on the inside by pressing down and dragging the tip of a bone folder along the fold lines, using a ruler as a guide. I make sure the box folds together properly before applying glue.

3 I then glue the bottom and one side tab of the box.

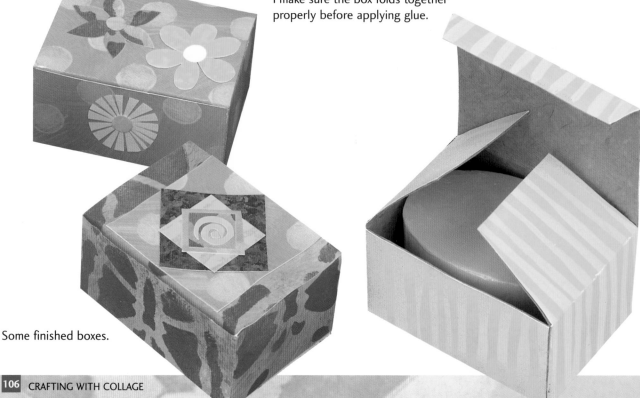

Some finished boxes.

hardcover box with lid

I will demonstrate two different approaches to making and decorating a hardcover box with a lid. The first is appropriate for a shallow box (no more than about 2 inches in height), such as one that would contain a book or a set of taper candles. The second approach works well for taller boxes. The construction is the same, but the paper covering is applied in a different way.

To make a lid, follow the directions for the shallow box, cutting the mat board $1/4$ inch larger in length and width. Cut the sides to the depth you want the lid to be. Once the lid is completed, you can make a collage on the top of it.

To make and cover a hardcover box, you will need mat board or illustration board; masking tape; a bone folder; lokta or other strong, flexible paper for covering the box; and paper or corrugated card to fit inside the bottom of the box.

Step-by-Step Project: **SHALLOW BOX**

1 First I decide on the dimensions of the box, then cut and mark a piece of mat board according to the template on page 127. I score the mat board along what will be the bottom edges of the box. The cuts should go about halfway through the board. I fold the sides up and secure them with masking tape.

2 I cut two pieces of lokta the length of the box less about $1/8$ inch, and two pieces the width of the box plus $1/2$ inch. The width of all four pieces of paper should be twice the height of the box plus 1 inch.

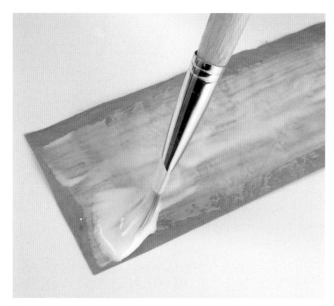

3 I then fold all my pieces of paper lengthwise. Starting with the shorter sides of the box, I apply glue to each piece of paper . . .

4 . . . and place the crease glue-side down on the top edge of the box, smoothing the paper over the box. For the short sides of the box, the papers will overhang the edges.

5 I smooth the inside corners using a bone folder.

6 This is what the outside corner should look like.

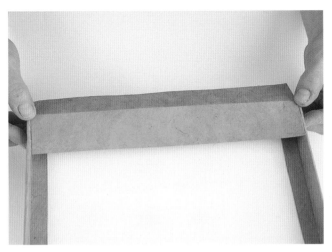

7 I apply the paper to the long side of the box. Notice how the paper comes to the inside edge of the adjacent sides.

8 I then glue the corrugated card to the inside of the box. (The finished box is shown on page 89.)

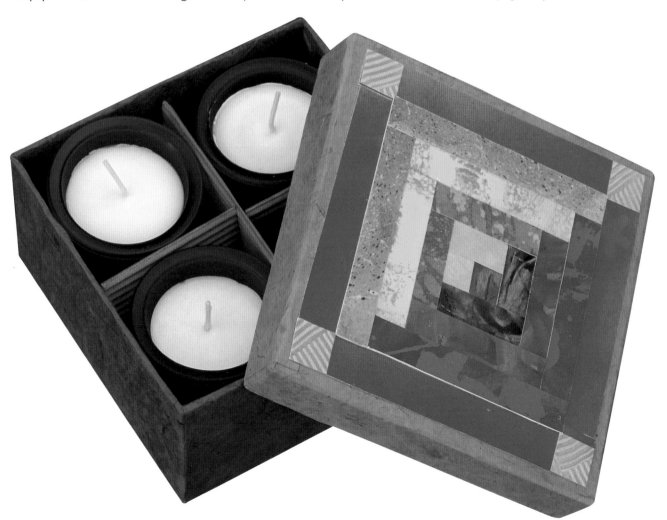

This box is collaged with a traditional log cabin quilt block design.

To make a taller box, follow the same procedure for cutting and taping the mat board, but instead of cutting four separate pieces of paper to cover the sides individually, you will cut one piece of paper that will wrap around the circumference of the box. This procedure works well for boxes over 2 inches deep.

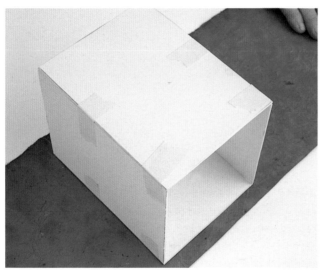

1 First I cut a piece of paper to fit all the way around the box with about ¹/₂ inch overhang at the top and bottom. I apply glue to the paper and wrap it around the box. A bone folder helps make the edges crisp.

2 Next I glue the paper around the bottom of the box as if I'm wrapping a package.

3 I then cut and glue a piece of paper to the bottom.

4 To cover the inside of the box, I cut a piece of paper about an inch longer than the bottom of the box in each direction. I cut the corners diagonally about ¹/₂ inch and glue this piece to the inside bottom of the box, smoothing the edges with a bone folder.

5 The flaps created by the diagonal cut overlap to make a neat inside corner.

6 To cover the inside of the box, I cut two pieces of paper about 1 inch longer than half the circumference of the box, and about $1/2$ inch less than the height of the box in width. I then glue one piece of paper to the inside of the box. I repeat the procedure for the other half and smooth the inside corners with a bone folder.

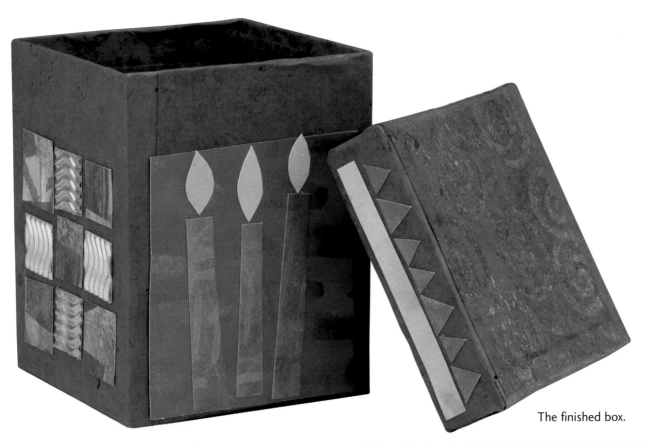

The finished box.

ribbon-top box

This ribbon-top construction is another way of making a lid for a box. The box itself can be made in the same manner as the hardcover box, or you can make a simple folded box following instructions on page 106, but leaving out the top and the top flaps. The box I am making in this demonstration is shown on page 96.

Step-by-Step Project: **RIBBON-TOP BOX**

1 The ribbon-top lid should be about ¹/₂ inch larger than the box. I cut my decorated paper using the template on page 127, make the folds, and cut two slits, slightly wider than my ribbon, equidistant from the corners on each side.

2 I then thread my ribbon in and out of the slits, making sure it goes around the outside of each corner and out the front, and tie a bow with the loose ends.

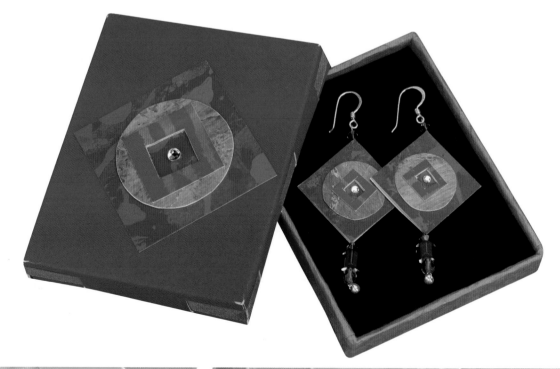

For this box I have glued the ribbon to the inside so that it does not have a bow. This is an example of coordinating the imagery on the box with its contents.

Decorative Objects

Making decorative objects, such as the hanging ornaments and prayer flags demonstrated here, allows you to indulge your sense of whimsy and your passion for decorating. They can be as simple or as elaborate as you like, and you can also include beads, tassels, rhinestones, sequins, and all manner of glitz and glitter. This is especially applicable to hanging ornaments, which can be made for specific holidays or everyday enjoyment. You can also use decorative objects as vehicles for verbal or symbolic content. The prayer flags offer a traditional format for such content, or they can be purely decorative.

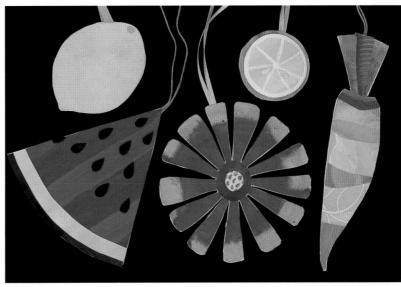

This group of ornaments makes use of fruit, vegetable, and flower themes.

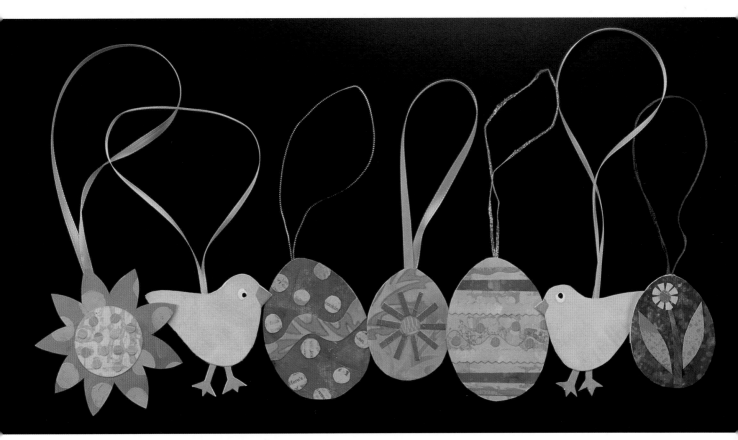

Hanging ornaments can be for everyday decoration or for a specific holiday. These cute chicks and eggs make charming ornaments for Easter; they can be hung from a branch or in a window.

hanging ornaments

Hanging ornaments are fun and easy to make and a great use for your hand-painted papers. A single handmade paper ornament or a set of them can make a very special hostess gift during the holidays. Making ornaments can also be a fun social activity for the family or a group of friends.

The paper ornaments described here consist of a piece of plain heavyweight paper sandwiched between two decorated papers. Cord or ribbon is glued within these layers for hanging the ornament. Once this basic structure is completed, you can embellish it with collage and other decorative materials.

Step-by-Step Project: HANGING ORNAMENTS

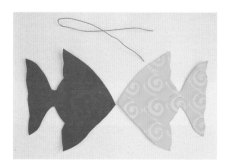

1 I first cut out my shape on plain white watercolor paper or heavy card stock and trace it onto a decorative paper. I then turn it over and trace it onto another decorative paper. I cut out my tracings and make sure all the edges fit together evenly.

2 I then glue the decorated cutouts to either side of the plain cutout, inserting a decorative cord between two of the layers. It is a good idea to weight down the ornament with a few heavy books, first wrapping it in waxed paper, so that it will dry flat.

3 Once the glue is dry, I cut away any uneven edges. At this point I can decorate the ornament with paper collage. I can decorate it differently on either side or decorate one side only, depending on how it will be displayed.

Here is the finished fish ornament swimming among his friends. This construction method could also be used to make hanging mobiles.

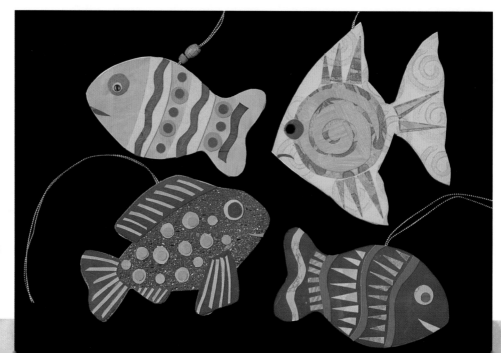

prayer flags

Prayer flags are strings of colorful flags with symbols and prayers written on them. Used as spiritual objects in Tibetan Buddhist culture, they are traditionally hung like clotheslines in high places or over rivers. It is believed that the wind blows through the prayer flags and carries the prayers throughout the area in which they are placed. The people in the vicinity of prayer flags are believed to benefit from their spiritual content, even if they do not read the prayers and symbols.

I got interested in prayer flags because their structure seems particularly adaptable to the presentation of visual imagery as well as verbal or symbolic content. A string of prayer flags is a kind of book in which all the pages are seen at once.

You could draw as many, or as few, parallels as you like between traditional Tibetan prayer flags and your own collages presented in this format. For example, you could create images that have spiritual symbols and text and hang them in a place that gives them special meaning. On the other hand, you could use the format to present groups of images that do not particularly relate to the prayer flag tradition, but relate to one another in a meaningful way.

The prayer flag structure consists of several pieces of paper folded and glued over a cord. Traditional prayer flags are placed very close together on the cord. Here, however, I have included beads between each flag just because beads offer another whole realm of decorative possibilities.

Step-by-Step Project: PRAYER FLAGS

1 I cut as many sheets of paper as I plan to include in my string of flags and fold each in half. I apply glue to one side of a folded piece of paper.

2 Folding the paper over the cord, I make sure the cord is snug against the crease.

3 I string beads on one side of the first prayer flag and then the other. I add the next prayer flag, making sure the edge comes right up to the beads. I do the same with all of my flags. My flags are now ready to decorate.

ABOVE: My yoga-theme prayer flags and a set of traditional Tibetan Buddhist prayer flags. I have chosen a yoga theme for my set of prayer flags, depicting a different yoga asana, or posture, on each flag. Other ideas for using this format include photos of family members framed in paper collage and a set of "kitchen prayer flags" with fruit and vegetable imagery or recipes. You could also present your "ten collages" warm-up exercises (see chapter 4, page 94) as a set of prayer flags, or a "Happy Birthday" banner could be made using this method.

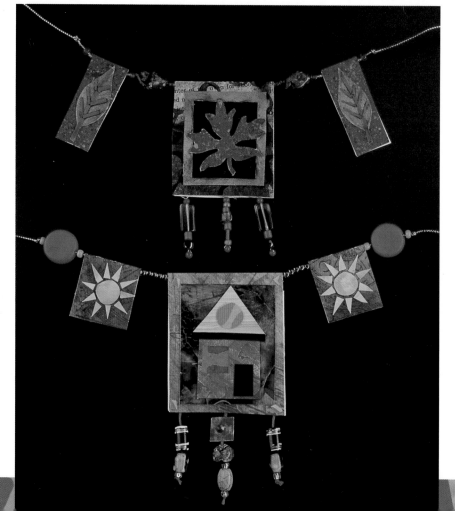

I made these two necklaces using the same method as for the prayer flags.

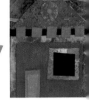

The same basic techniques for making hanging ornaments and prayer flags can be applied to making paper jewelry. This is a fun way to make use of small scraps of decorated papers, and to incorporate beads and rhinestones in your designs. I use the same decorative cord for necklaces as I use for ornaments, but for earrings beading wire works best.

Beading wire is available at craft supply stores in several thicknesses, or gauges, and in many colors. For the following demonstration I use fine gold wire for stringing the beads and a heavier silver wire for the hanging mechanism. Jewelry findings, such as ear wires, posts, clasps, jump rings, pin backs, and so forth, can be found at craft supply and bead stores.

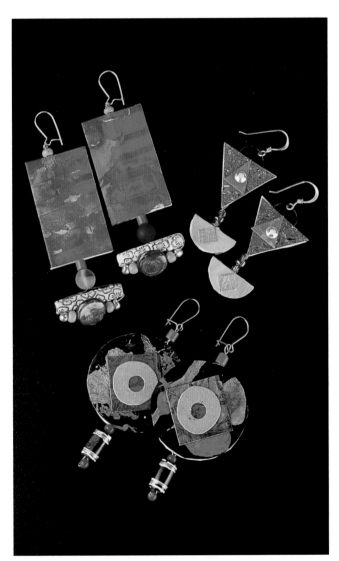

Several pairs of earrings made with decorated papers.

This necklace is made by looping the beading wire over the cord before sandwiching it between the papers.

earrings

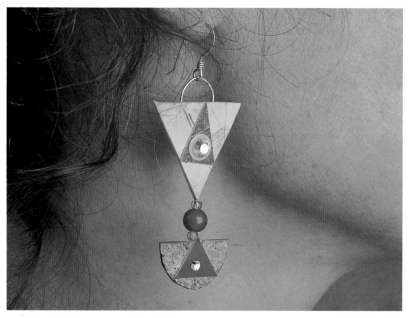

For a pair of earrings, first sketch your design and cut out the parts. Don't forget to cut out a blank piece of paper to sandwich between the front and the back for each paper component. Laminate each component with the blank paper, then assemble each earring as you would a hanging ornament, adding beads if you wish.

I find it easiest to apply the paper collage before assembling the earrings. After the piece is assembled, I apply a coat of matte or gloss medium to both sides of the earring, then add the rhinestones or sequins.

Your earring designs can be elegant or whimsical, simple or complex.

Step-by-Step Project: EARRINGS

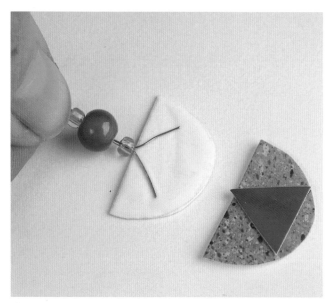

1 I string beads on a wire and then assemble the lower part of the earring.

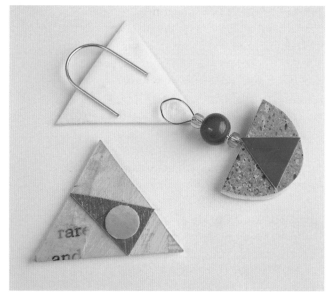

2 The upper part of the earring is ready to be assembled.

Collage can be used to decorate ready-made objects such as tea tins, wine bottles, glass jars, boxes, and other discards, transforming them into unique decorative accessories. At craft supply stores you can usually find a variety of wood and papier-mâché objects such as boxes, trays, ornaments, birdhouses, and so forth, which are ideal for this application. Vases in all shapes and sizes, as well as glass canisters, candlesticks, and decorative plates (not plates you eat off of) are some examples of glassware you can decorate with collage. The advantage of glass is that it is watertight, and thus functional.

The process is basically the same for any kind of three-dimensional object. First, if the object is made of a nonporous material such as glass or metal, prime the surface to be collaged (the outside only for glass vases) with an all-surface acrylic paint or primer. Since you will be completely covering this primer with paper, it does not matter what color you use. If your object is wood, cardboard, papier-mâché, bisque pottery, styrofoam, or any other porous material, it need not be primed. The next step is to cover the object with lokta or some other strong but flexible paper. There are several methods of measuring out the needed amount of paper, depending on the geometry of the object to be covered. These methods are demonstrated below.

Once the surface is covered you can begin to collage with your decorated papers. For curved pieces, decorated lokta is ideal for collage as well as for covering the piece, as it more easily molds to the surface than does watercolor paper. However, your watercolor paper can work on curves if the pieces are relatively small. You can think of

this process as "paper mosaic"—using small pieces of paper to build imagery or patterns. When your collage is finished and the glue is dry, apply one or two coats of acrylic gloss medium or matte medium, or a combination of the two for a satin finish. Make sure the medium penetrates all the nooks and crannies in the paper, but don't let it pool. This will give your piece a finished look and also make it water repellent.

I covered this wine bottle and canisters with lokta and then collaged them with pieces of patterned papers. Applying a couple coats of acrylic medium to the collaged objects will give them a finished look and make them water resistant.

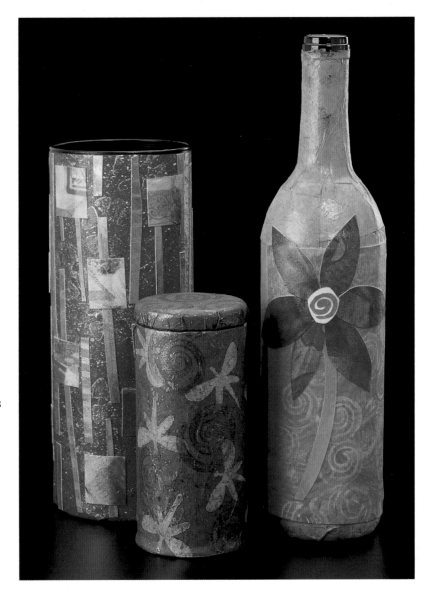

covering a cylindrical box

Cylindrical pieces can be covered in much the same way as hardcover boxes (see pages 107 to 109), but you need to employ a different technique to fit the paper around the circular bottom. To demonstrate this procedure I covered a papier-mâché hatbox I purchased at a craft supply store. I first covered the inside using orange lokta, and then the outside with magenta lokta. I covered the lid on the outside only, not on the inside, so that it would fit over the box.

Step-by-Step Project: **COVERING A CYLINDRICAL BOX**

1 To cover the inside of the box, I cut a circle about ¹/₂ inch bigger than the bottom of the box, and a strip of paper slightly narrower than the height of the box and long enough to go around the circumference of the box with some overlap.

2 I trace the bottom of the box on the circle of paper, and cut slits about ¹/₂ inch apart so that it will fit smoothly inside the bottom of the box.

3 I then apply glue to the back of the circle and gently fit it into the inside bottom of the box, using a bone folder to establish the crease. The tabs created by the slits should overlap slightly, allowing the paper to fit smoothly.

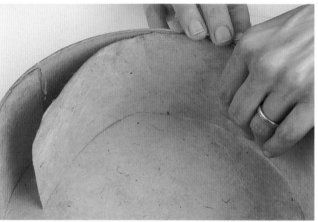

4 Next I glue my strip of paper to the inside of the box.

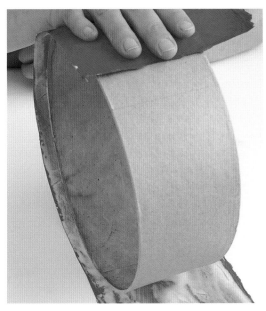

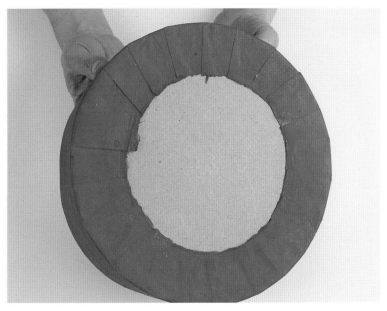

5 To cover the outside of the box, I cut a strip of paper long enough to wrap around the circumference with some overlap. The width should be the height of the box plus at least $^1/_2$ inch overhang on both top and bottom. I apply glue to the paper and wrap it around the box.

6 While the glue is still wet, I cut slits in the paper at the bottom and glue them down to the bottom of the box. The tabs overlap around the bottom of the box. If your glue dries before you get to this point, just reapply it to the overhang before cutting the slits. I then fold the paper over the top edge of the box and glue it down.

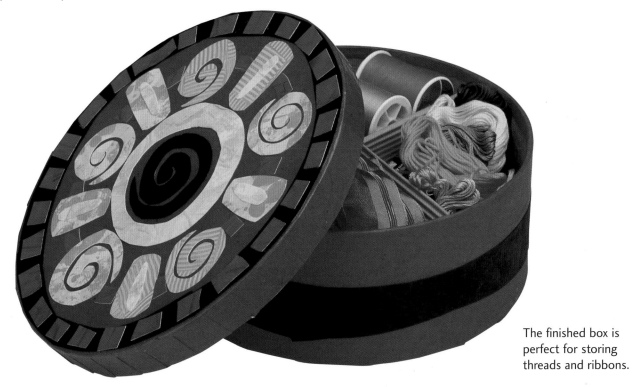

The finished box is perfect for storing threads and ribbons.

covering a curved object

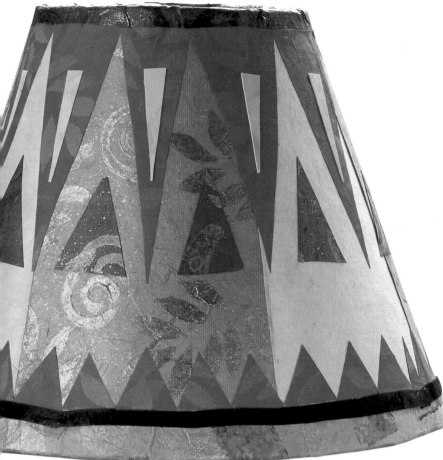

Curved or spherical objects, such as vases and wine bottles, are a little tricky to cover with paper. As you glue the paper down, it will inevitably buckle around the curve. To minimize this effect, first use smaller pieces of paper around curved areas. Then, cut slits in the edges of the paper and overlap the resulting tabs (for a convex curve) or spread them out (for a concave curve) as you glue the paper over the curve. If you sew, you will be familiar with this process. There will inevitably be some little wrinkles and overlaps on a curved piece; this is part of the character of a collaged object. For the demonstration at right I covered a glass fishbowl with bright turquoise lokta paper to make a vase.

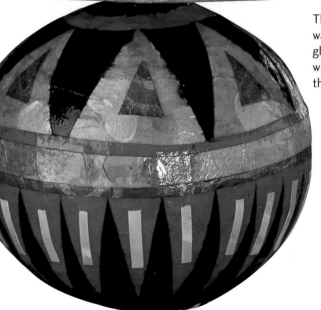

This colorful lamp was made from a glass vase I covered with lokta paper and then collaged.

Step-by-Step Project: COVERING A CURVED OBJECT

1 First I paint the fishbowl with an all-surface acrylic paint so that the glue will have better adhesion.

2 To fit the paper around the curve of the fishbowl, I cut slits in it and overlap the tabs as I glue them down.

3 I smooth down the paper with a bone folder as I go.

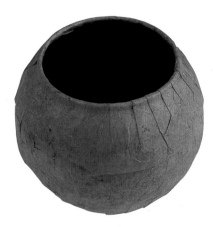

4 I fold the paper around the rim of the fishbowl; it is now ready to be decorated with collage.

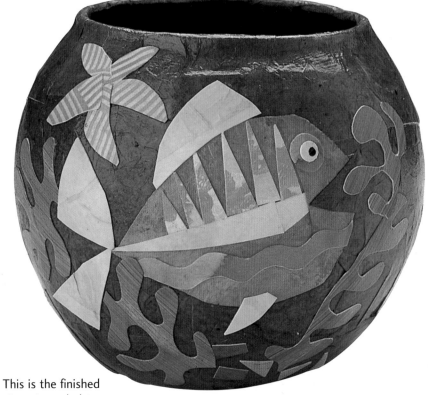

This is the finished piece, intended to be used as a vase.

covering tiles & other flat objects

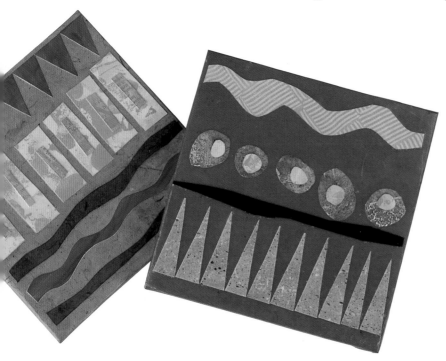

I made these individual tiles to use as trivets.

Paper-covered tiles can be used individually as trivets or coasters, or they can be set into a frame to make a tray. You could even use them to tile the top of an end table. I used a 6-inch unglazed ceramic tile for the demonstration below, but you could use a glazed tile, a thin piece of masonite, or even two pieces of heavy illustration board laminated together. I apply two or three coats of polyurethane over two coats of acrylic medium to the collaged tiles to make them durable and impervious to water. If you are setting tiles into a frame, the edges should butt up against each other with no space for grout. Set the tiles first, and then apply the polyurethane, letting it settle into the cracks between the tiles. To make a trivet or coaster, apply self-adhesive cork to the back of the tiles.

Step-by-Step Project: COVERING TILES

1 I first cut a square of paper large enough to overhang the tile by about an inch on all sides.

2 I apply glue to the paper and set the tile in the middle. I then cut the corners on the diagonal to within about 1/4 inch to make a smoother fold.

3 I fold in the corners with a bone folder, and then apply glue to the fold before wrapping the paper around the tile.

4 The back of the tile, once it is covered with paper.

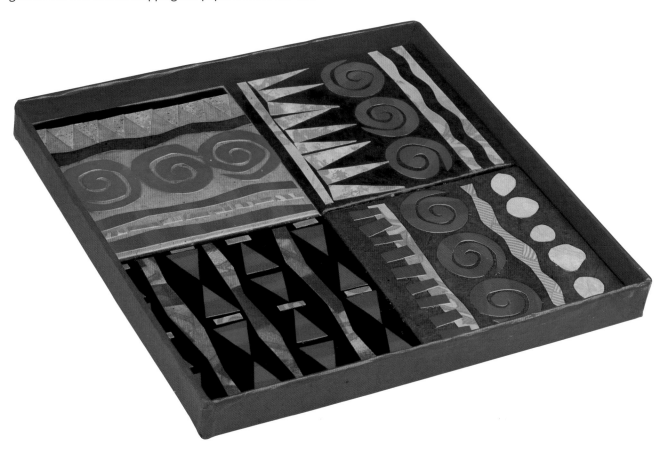

The frame for this tray is constructed using the method for the shallow box on page 107.

Templates

To make some of the projects in the book you will need to use templates to cut out the pieces. You can either photocopy the pages or use tracing paper to copy them. The templates are not shown at full-size, so feel free to enlarge them to any size you would like to use.

Quilt Card
(Instructions on page 85.)

Pop-up Card
(Instructions on page 99.)

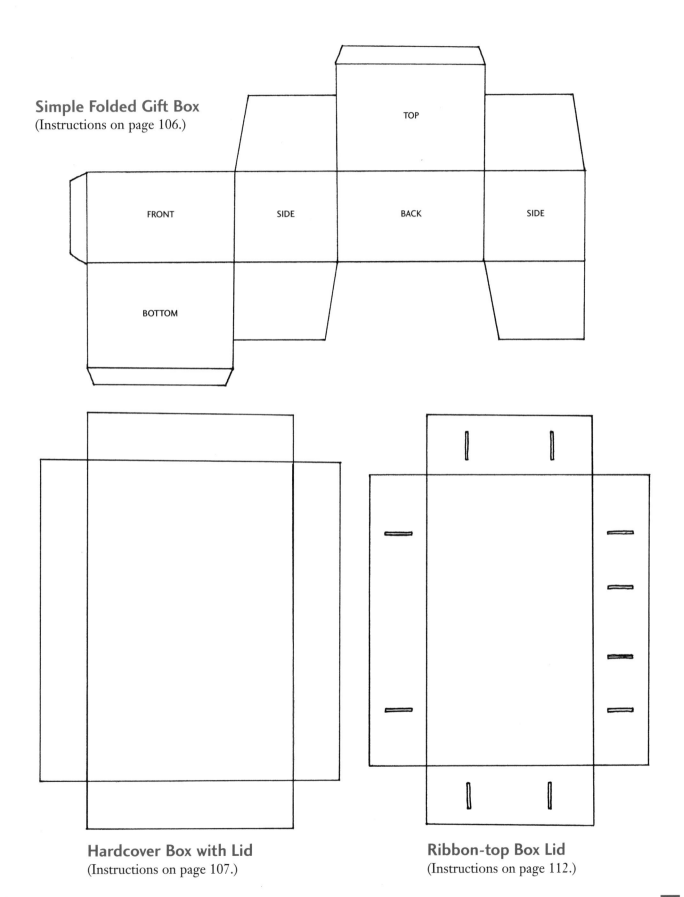

Simple Folded Gift Box
(Instructions on page 106.)

TOP

FRONT

SIDE

BACK

SIDE

BOTTOM

Hardcover Box with Lid
(Instructions on page 107.)

Ribbon-top Box Lid
(Instructions on page 112.)

Index